CHIHULY PERSIANS

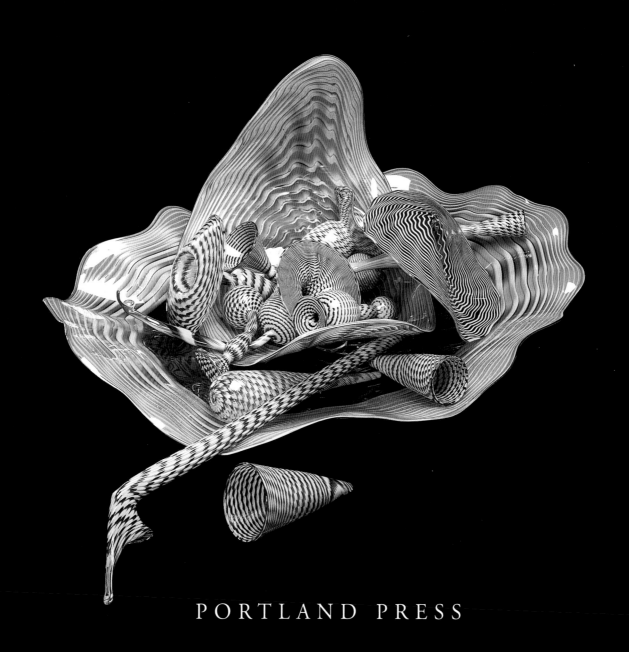

PORTLAND PRESS

Text and photographs copyright ©1996 Portland Press
All rights reserved.
ISBN 1-57684-004-2

First printing, 1996, 5,000 copies.
Second printing, 1999, 10,000 copies.
Printed by C&C Offset Printing Co. Ltd., Hong Kong.

Portland Press
P.O. Box 45010
Seattle, Washington 98145-0010 USA
800-574-7272

Library of Congress Cataloging-in-Publication Data
Oldknow, Tina 1950-
 Chihuly Persians/essay by Tina Olknow.
 p. cm.
 ISBN 1-57684-004-2
 1. Chihuly, Dale 1941- –Criticism and interpretation.
2. Glass art–United States–History–20th century. I. Title.
NK5198.C43043 1996
730′.92–dc21 96-48512
 CIP

Cover and title page: *Cadmium Yellow, Lavender & Chrome Green Persian Set*, 10 x 37 x 21 in., 1988.

CHIHULY PERSIANS

ESSAY BY

TINA OLDKNOW

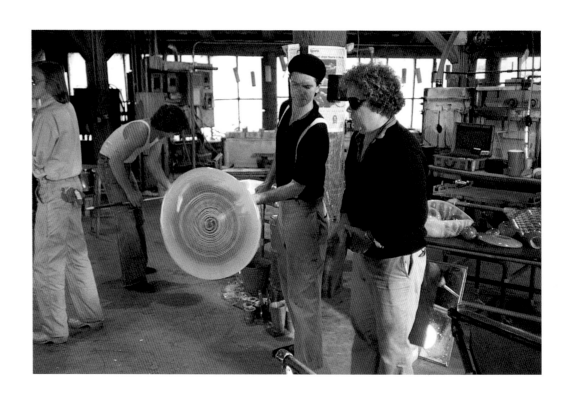

This book is dedicated to all
of the glass blowers who made
the Persians.

Thank you for all of your skill,
teamwork & creativity. without
you of course there would be
no book.

Chihuly

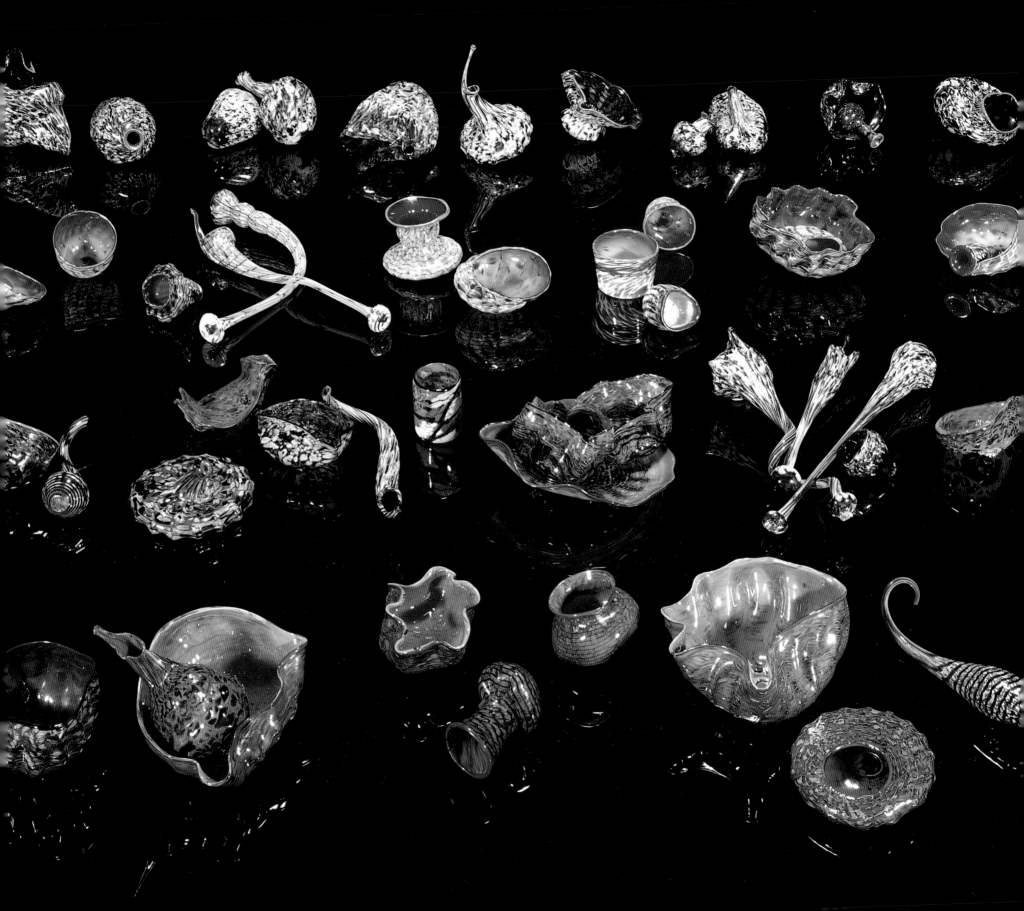

AN ANCIENT LEGACY

God is the light of the Heavens and the Earth.
His light is as a niche in which is a lamp,
The lamp in a glass,
The glass, as it were, a glittering star.

The Koran[1]

VESSELS

The first Chihuly *Persians* were made in 1986. An eccentric collection of brightly colored and unusually shaped objects—primarily small bottles and vessels—the earliest *Persians* looked "archaeological" to Chihuly, like excavated ancient treasures. Chihuly sensed that these objects represented a formal direction in his art that was experimental, new, and exotic. Exhibited for the first time in Chihuly's 1986 solo exhibition at the Musée des art décoratifs of the Palais du Louvre in Paris, the *Persians* were described in the exhibition catalogue as "new possibilities from the blowpipe."[2] At the time of the Louvre show, the series was still untitled.

"In the beginning, the *Persians* had to do with the contrast between two colors . . . between open and closed forms . . . and the intensity of the body wraps," Chihuly has recalled. ("Body wrap" is Chihuly's term for the stripe of color applied to the body of a piece.) Soon, the early *Persians'* color-saturated, contrasting body wraps were seen by the artist as alternately "Persian," "Byzantine," and "minaret-like," almost "Persian and Roman too." More interested in the East than the West, Chihuly liked the sound of the word "Persian," the associations it inspired, and the series found a name.[3]

In discussing Chihuly's work, the artist and art critic Walter Darby Bannard has observed, "There is a popular misconception that great modernist art always makes a radical break with the past. In fact, very good, new art often breaks with

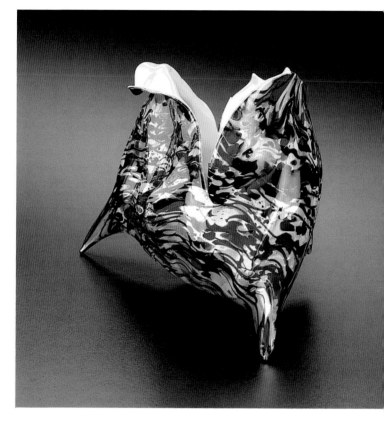

Dale Chihuly, early *Persian*
form, 1988.

Left: Dale Chihuly, experimental
Persian forms, 1986.

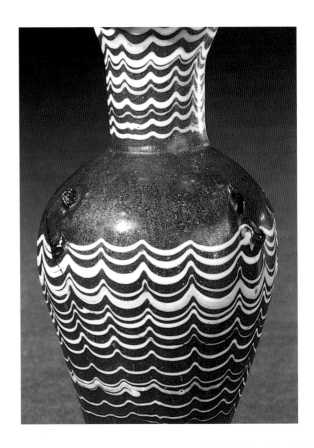

the present by going back to the past."[4] While Chihuly's art is undeniably of the present, the presence of the past is manifest. In Chihuly's *Persians,* I see a profound connection to the past, but it is a subtle and mysterious connection, as complex as the history of Persia itself and as unconscious as the intricate path of its cultural legacy. What is Persian about Chihuly's *Persians*? Persia's past, the past of glass, and the larger context of the Near East will offer some answers.

With their opaque and vivid, contrasting colors, Chihuly's early *Persians* hint at glass's distant past: the small, dense, and rare core-formed vessels that first appeared in Egypt about 1500 B.C. and in Mesopotamia (Iraq) around 1300 B.C. Several types of core-formed vessels were popular in ancient Egypt and Mesopotamia, where they functioned, among other things, as cosmetic tubes for kohl, the distinctive black eye makeup worn by Egyptian women. Similar vessels were used by classical Greeks as containers for scented soaps and oils. Core-formed wares were made by carefully winding ribbons of molten glass around a primarily clay core, and then picking out the core after the glass had cooled. Their production in the eastern Mediterranean region peaked from the 6th through the 2nd century B.C.

Core-forming and other early techniques, such as casting, were eclipsed around the middle of the 1st century B.C. with the discovery of glassblowing, a technological leap that dramatically affected the ancient glass industry. Blowing glass enabled Roman glass manufacturers to expand the trade from the elite practice that it was in earlier times to a profitable commercial enterprise mass-producing products everyone, citizen or slave, could afford to own. In spite of its transformation from a labor-intensive luxury medium into an inexpensive material, glass was still sought after for finer wares, such as the elaborately decorated glasses that rivaled items made of precious stones, silver, and gold.[5] In the Roman novel

The Satyricon one of the characters, a wealthy nobleman named Trimalchio, expounds upon the merits of the versatile new material, claiming that glass vessels would be better than vessels made of bronze, and even vessels made of gold, were glass not so breakable.[6]

PERSIA

Some of the most outstanding glass objects to survive antiquity are the cast and cut vessels made by Persian artisans during the 5th and 4th centuries B.C. The powerful Persian empire was centered at the royal Achaemenid complex at Persepolis, located in southwestern Iran, near modern Shiraz. Ancient Persepolis was renowned for its splendid architecture and the opulent lifestyle of its wealthy and learned court, where exquisitely cast-glass bowls, molded in the shape of large rosettes, were among the royal accoutrements presented at official court occasions. The Greek playwright Aristophanes, writing around 425 B.C., relates that rock crystal-like glass bowls were provided to Greek ambassadors attending diplomatic functions at Ecbatana, the former Median capital and Persian stronghold.[7]

Persepolis was founded by the Achaemenid Persian king Darius I (reigned 521-486 B.C.), who expanded the empire founded by his predecessor Cyrus the Great (reigned 549-530 B.C.). It is thought that Persepolis served not only as a royal residence and administrative center for the Persian empire but also functioned as the primary locale for the celebration of the New Year each spring, the most important ritual event of the Persian calendar. The famous reliefs showing Persian dignitaries and tribute-bearers lining the double staircase leading to the apadana, or audience hall, at Persepolis are thought to mirror actual events that took place there during the New Year festivities.[8] Ceremonies included the presentation of gifts from the empire's subject peoples: the precious bowls carried by

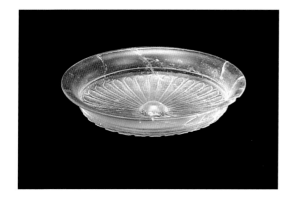

Colorless cast glass bowl,
6 7/8 in. in diameter, Iran or
Mesopotamia, 5th-4th century
B.C. © The Corning Museum
of Glass

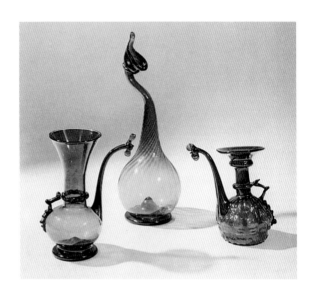

Chihuly's *Persian* sets often incorporate intricate shapes similar to the Persian glass vessels pictured above. 17th and 18th centuries. © Cooper-Hewitt Museum, gift of Rodman Wanamaker

delegates, as shown in the reliefs, may represent works in metal or glass.[9]

Alexander the Great, still a relatively young man, died at Babylon in 323 B.C., only seven years after the sack of Persepolis by his armies. The Persian lands, representing a fraction of Alexander's empire, which extended from Greece to India, were passed on to one of his top generals, Seleucus (reigned 312-281 B.C.), the founder of the Seleucid dynasty. The Seleucids ruled Persia for nearly 150 years, until the conquest of Iran by the nomadic Parthians in 141 B.C. The Parthian's hold over Persia gradually declined as the Romans made inroads into Parthian territory, but they were ultimately deposed by the Sasanian Persians in the third century A.D. The Sasanians sought to revive the ancient Achaemenid empire of Cyrus and Darius and the sophistication of their courts. They reinstated many of the early Persian traditions, among them the crafting of thick-walled, spectacularly wheel-cut, luxury glass vessels.[10]

Some three hundred years later, the Sasanians were expelled from Persia by invading Muslim Arabs in 651. With this conquest, Persia became one of the many Near Eastern cultures to be subsumed into the powerful and growing empire of Islam and would remain forever under the aegis of the prophet Mohammed. Thus, the concept of "Persia" does not end with the grand and ancient empire but must include the scholarly, courtly world of Islam.

BYZANTINE AND ISLAMIC GLASS

Considering the momentous advances in glass technology and decorative techniques during the height of the Roman empire—from the 1st century B.C. to the 3rd century A.D.—the following thousand years, for glassmaking at least, were relatively quiet. While western Europe fell prey to invasions of marauding tribes after the fall of Rome in the 5th century A.D., what was once the eastern Roman

empire, centered at Constantinople (Istanbul), flourished under Byzantine Greeks. Lasting nearly a thousand years, the Christian Byzantine empire was dealt its final blow with the sack of Constantinople in 1453, at the hands of the Muslim Ottoman Turks.

Even today, Byzantine glass production remains somewhat mysterious. Ancient tax records reveal that glass was made in Constantinople, and it is said that at Corinth, on mainland Greece, the first pane glass, used for glazing, was made.[11] Although Byzantine art is renowned for outstanding glass mosaics, preserved in Byzantine sacred architecture, the few glass vessels that have survived tell us little about the full range of glass objects that might have been available in Byzantine times. Known examples generally tend to be rudimentary blown and mold-blown wares, or they are the kind of spectacular luxury object—cast, blown, cut, and enameled—belonging to the treasury of the basilica of San Marco in Venice. Glass vessels from classical antiquity have been preserved by the thousands in ancient Roman tombs, but Christian burial customs discouraged the interment of grave gifts with the deceased. As a result, there is not as complete a picture for Byzantine and western Medieval glass, in terms of quantity and available forms and colors, as there is for earlier Greek and Roman cultures.

When the Byzantine capital of Constantinople was first taken and plundered during the Fourth Crusade in A.D. 1204, European crusaders absconded with a variety of art treasures, including glasses with enameled and gilt decoration. It was during this raid that the famous glass objects in the treasury of San Marco were brought to Venice by Venetian crusaders returning from the Byzantine capital. Whether those splendid objects were Byzantine, though, is now a matter of debate. Like the exquisite enameled and gilt glasses brought to Europe at that time, it is thought that the San Marco glass vessels may have been of Islamic rather than

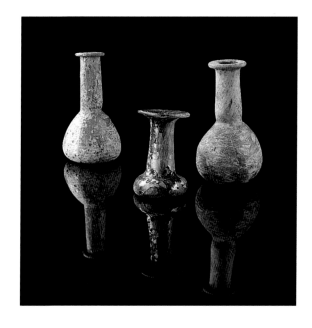

Ancient Roman glass in the private collection of Dale Chihuly.

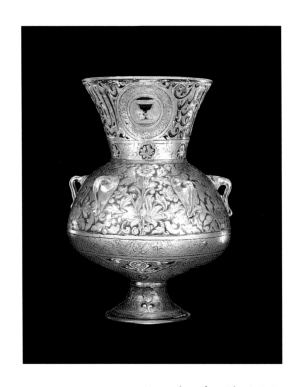

Mosque lamp from Islamic Syria,
12 in., A.D. mid-14th century.
This glass lamp is handblown,
enameled, and gilded. © The
Corning Museum of Glass

Byzantine origin. Because of the pervasive Oriental influence on Byzantine decorative arts and textiles of the period, distinctions between purely Byzantine and Islamic design elements have proved difficult to make.[12]

In the meantime, Persia and Syria, under Muslim hegemony from the 7th century on, were governed by a succession of Ummayid and Abbasid dynastic rulers. Syria was an important glassmaking region throughout antiquity, and its glass industry continued to be strong after the fall of Rome, although it was rivaled in Islamic times by important centers at Baghdad and Cairo. After the Mongol invasions of Persia and Mesopotamia in the middle of the 13th century, Syrian glass production rose to the fore. The 13th and 14th centuries in Syria—the period of Ayyubid and Mamluk rule—represented the pinnacle of Islamic glass manufacture and remains one of the most important achievements in the entire history of glass.[13] In addition to their elaborate cut-glass vessels, Islamic glassworkers were known for luster-painting, a decorative technique first practiced in Egypt around the 7th to 8th century and in Persia after the 9th century. Luster-painting, or painting with metallic oxide pigments to create semi-transparent, iridescent colors, was the precursor of the highly regarded Islamic techniques of enameling and gilding on glass, developed, it is thought, sometime between 1170 and 1270 at the Syrian city of Raqqa.[14] The finest enameled and gilt wares for which Islamic glassmakers became famous, however, were produced not at Raqqa but at the Syrian city of Damascus.[15] Most prized of the Islamic luxury wares from Damascus were the richly enameled and gilt mosque lamps—actually lamp-holders or lanterns—which were illuminated by their enclosed oil-lamps.[16]

Islamic glass production abruptly ceased when Damascus and Aleppo, in Syria, were overrun in 1400 by the Turco-Mongol armies of Timur, a central Asian Muslim warlord known in the West as Tamerlane. This vacancy was soon filled by

the rising Italian industry, centered in Venice, which would grow to dominate European glass manufacture. The demand for Islamic-style glass did not end with the Syrian industry, and Venetian glassmakers carried on Islamic-style productions, in addition to their own celebrated designs, for the next two centuries.[17]

VENICE

The practice of decorative enameling and gilding on glass by Venetian craftsmen, which peaked around 1500, is thought to be inherited from the Islamic glass industry. Certainly, the Venetian republic had maintained close trading contacts with the Near East and was producing Islamic-style glass and textiles.[18] Some historians see Muslim influence in the architecture of Venice, such as the preference for domes decorated with polychrome inlays or the Venetian love of gardens, courtyards, and fountains.[19] But it is more likely that these influences spread to Venice from Byzantine Constantinople. Not only was Venice the "favorite daughter of Byzantium," a title given to the city in 1000 by the Byzantine emperor Basil II,[20] but the Venetian Doge Pietro Ziani went so far as to propose in 1222 that the entire city of Venice be abandoned and moved to Constantinople. Legend has it that Ziani's controversial motion was defeated in the Venetian senate by only one vote.[21]

Concerning the origins of Venetian glass, some historians believe that there is no way of establishing whether Venetians acquired the techniques of enameling and gilding on glass from Islamic glasshouses or Byzantine ones, but that because of Venice's long-standing relationship with Byzantium, it was from artisans of that empire whom early Venetian glassmakers sought direction.[22] The most detailed description of glassmaking in the Middle Ages is preserved in a treatise, entitled On Divers Arts, authored by a German Benedictine monk under the pseudonym

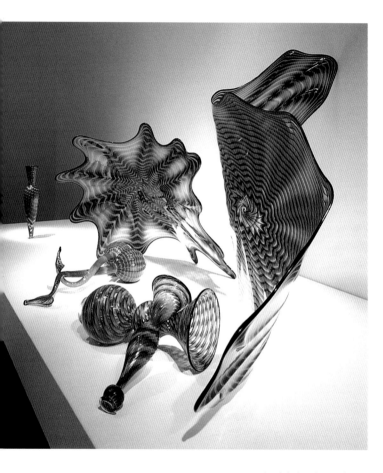

Dale Chihuly, *Blue and Gold Persian Set*, 1988.

Theophilus. Writing in the early 12th century, Theophilus recorded the Byzantine Greek practice of making "blue stones [glass mosaic tesserae], and precious goblets for drinking, embellishing them with gold." The monk also carefully described how Byzantine glassmakers prepared their enamels: "White, red and green glass, which are used for enamels, are carefully ground, each one separately, with water on a porphyry stone. With them, the [Greeks] paint small flowers and scrolls."[23]

Byzantine traditions abound in the architecture and rich decoration of the Venetian basilica of San Marco, originally the chapel of the Palace of the Doges, the august governors of the Venetian republic. Begun in the 9th century—at which time the relics of the evangelist Mark were "acquired" (that is, stolen) from Alexandria, in Egypt[24]—the great church was built primarily during the 11th century, but not completed until the 13th century.[25] San Marco has been described as an "eloquent memorial" of the Byzantine contribution to Venetian culture, "a living symbol of the close relations between Byzantium and Venice."[26] At the same time, San Marco is said to have unmistakably Islamic features, such as the arch of the Door of the Flowers, but that, for the most part, "the Byzantine and Islamic elements harmonize so perfectly that is difficult to distinguish one from the other."[27]

The magnificent bronze horses of San Marco, which dominate the facade above the basilica's main doorway, are another important example of the profound connection between Venice and Byzantium, reflecting the Byzantine fusion of classical Western and Eastern traditions to which the architecture and culture of Venice is indebted. Their source, like much of Venice's own history, is shrouded in mystery, and while many theories abound about their origins, none are provable. The only sure element of the horses' history is that they found their way from Constantinople to Venice, as crusader war booty, in 1204.[28]

VENETIAN GLASS AND ART NOUVEAU

As the late curator Henry Geldzahler noted, there is a correlation between Dale Chihuly and the champion of American art nouveau, Louis Comfort Tiffany, in their understanding of, and interest in, the history of glass.[29] The New York Times critic Holland Cotter has also seen in Chihuly's work "the painterly, chromatic complexity of Venetian glass and the sensuous curves of art nouveau."[30] Because of Louis Comfort Tiffany, the ephemeral, iridescent colors of ancient Roman glass and ancient combed decoration were revived, becoming central to the aesthetic of American art nouveau glass at the turn of this century.

Persian pottery as well as ancient glass were important influences on art nouveau, and of the many stylistic associations to be found in Chihuly's *Persian*, the art nouveau connection may be the most surprising. Although some of the more obvious art historical parallels for certain of Chihuly's *Persians* forms are the lily-leaf pitchers and long-necked bottles typical of 17th- and 18th-century Persian glass production, parallels may also be seen in the orientalizing designs produced by Tiffany Studios at the turn of this century, or the Bohemian (Czechoslovakian) art nouveau glass made by the firm of Pallme-Kônig & Habel around 1900-1920.[31] Certain *Persian* elements are also seen in post-World War II Venetian glass, specifically in the designs made by Swedish artist Tyra Lundgren for Venini Glass in 1948. Lundgren's series, called vetro fenicio, featured an asymmetrical, leaf-shaped lip and stripes of color, alternating with colorless bands, that imitated ancient and art-nouveau-style combed decoration.[32]

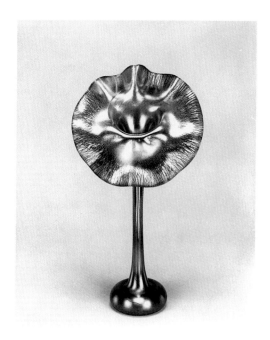

Jack-in-the-Pulpit Vase,
18 3/4 in., transparent dark
blue glass; blown, heavily
iridized, 1912. © The Corning
Museum of Glass

CHIHULY'S PERSIANS

For Chihuly, the city of Venice has held a continuing fascination. His 1968 residency in Venice, at Venini Fabrica on the island of Murano, introduced him not

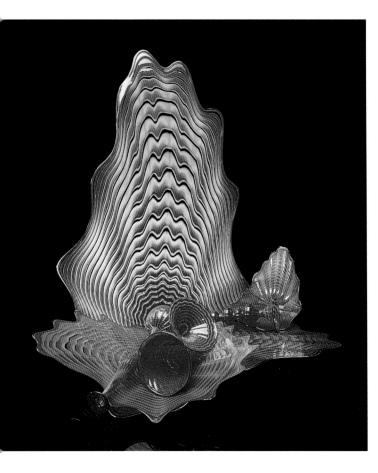

Dale Chihuly, *Cadmium*
Orange Persian Set with Blue
Lip Wraps, 21 x 22 x 19 in., 1990.

only to historic Venetian glassblowing techniques but also to a spirit of team-working, a gracious style of living, and an opulent color aesthetic that would become an important influence on his own design philosophy. In the catalogue published in conjunction with the artist's solo exhibition at the Seattle Art Museum in 1992, the curator Patterson Sims noted in his essay, entitled Scuola di Chihuly: Venezia and Seattle, that Chihuly's love of exotic and extravagant color was positively "redolent of Venetian art."[33] All the colors of Venice, from the luminous pinks of its incomparable twilight to the vivid, almost garish golds, reds, and bright stripes of its architectural exteriors and interiors are reflected in Chihuly's remarkably diverse palette. Subtle, intense, simple, complicated, dark, light: Chihuly's colors are his signature.

Culturally and aesthetically, Venice can be appreciated as a product of the Persian, Byzantine Greek, and Muslim East, rather than the Latin West, with the basilica of San Marco as an outstanding example of the characteristically Venetian assimilation of classical, Byzantine, and Islamic cultures. When I look at Chihuly's Persians, I imagine all the influences of these great ancient civilizations as well as modern art movements, such as art nouveau. But perhaps more than anything else, I see the riotous color, contrasting textures, and exotic, Eastern cast of Venice as the spiritual source of the Persians, celebrating the mystery and romance of Venice as much as the distant, yet powerful, presence of Persia and Byzantium.

INSTALLATIONS

Chihuly's *Persians*, with their expansive vocabulary of forms, multitude of colors, and varied scale, are particularly effective in large-scale contexts. "Ultimately, Dale's work reveals his understanding and continued respect for the vessel," observes James Carpenter, a New York-based artist and architectural designer who

collaborated with Chihuly on some of his most experimental work in the early 1970s. However, Carpenter adds, Chihuly approaches the vessel form "not as a container, but as an incredible environment."[34] Nowhere is this more true than in the *Persian* installations, where Chihuly plays with repetition and scale in his transformation of the hollow object from humble container to lavish environment.

Beginning with the small and experimental pieces, Chihuly gradually pushed his *Persians* into larger, more sophisticated groupings of color and form. The scale of these elegant groupings, in turn, swelled to become room-size installations. The critic David Bourbon, writing for Art in America, has described the irrepressible *Persian* installations as flamboyant corsages, "commanding attention for both the sheer gorgeousness of their undulating forms and for the spectacular manner in which they spill into the room, [their] ornate edges all but alive with potential movement."[35] The extraordinary vitality of the *Persian* installations is awe-inspiring, the pieces delicate and aggressive at the same time. The art historian Linda Norden recently touched on this contrast with her comment that the installations had taken on "an aspect of fecundity and self-proliferation which also may account for . . . their slightly threatening aura."[36]

For Chihuly, each *Persian* grouping represents an environment, and no matter how big or small, these environments remain conceptually linked to each other through their relationship to the space they inhabit. Chihuly, asserts the curator Sarah Bremser, is "primarily an installation artist. . . . When he conceives of an artwork, he is thinking not merely about how objects will be placed but how he can deliver a cogent and successful architectural, aesthetic and experiential statement. As the artist himself says, 'I am as interested in the way my art works in a space as in the art itself.'"[37]

The genesis of the Persian environments is, in hindsight, a logical progres-

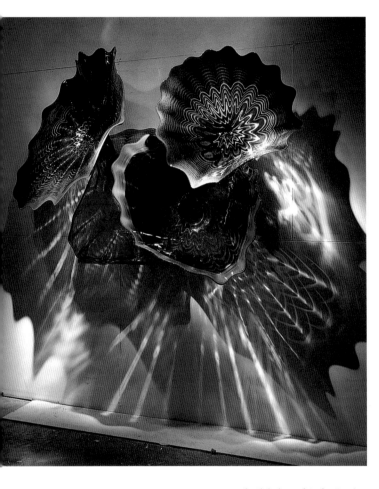

Dale Chihuly, *Multicolor Persian Installation*, 65 x 84 x 22 in., 1993.

sion, illustrating Chihuly's love of change and his desire to push his materials. The first *Persians* installations were little more than groupings of objects removed from their pedestals and placed on shelves. Next came the wall pieces. The earliest examples, such as the 1988 installation at Chancellor Park in La Jolla, California, combined *Persians* shelf groupings with wall-mounted pieces placed above the shelf, extending the surface area of the glass. Over time, smaller vessels disappeared from the installations, and the groupings became larger and fuller, turning into a collage on the wall, as in the 1992 installation at Union Bank Center in Seattle, Washington. The *Persians* then became more site-specific with window collages such as the 16 by 16 foot commission for Little Caesars corporate world headquarters in Detroit, Michigan, in 1993. With the transition from the adornment of space to the interpretation of it, Chihuly's *Persians* no longer could be regarded as discrete objects but as an environment to be experienced.

ENVIRONMENT

The *Persians* are most powerful when their color and form can envelope a space. "Dale's real forte is in sensing the value of an idea," remarks James Carpenter. "He has a very good interior sense of things so that, intuitively, in setting up an idea for a form, he develops an idea for its space as well. He has a sense of the way color changes an environment."[38]

From their enclosed wall and window environments, the *Persians* expanded to the floor for a 1991 installation in Kyoto, Japan—when Chihuly created a special enclosure by placing a collection of *Persians* beneath large glass plates. Liberated from their vitrines, they freely spread to windows and ceiling for the artist's solo exhibition at the Seattle Art Museum in 1992. The first truly "environmental" *Persians* at SAM showed the window and ceiling installations to be

ideal vehicles for the series. A 1994 window piece he created for Tacoma's Union Station was titled "*Monarch Window*", an association that aptly captures the sense of movement of the bewitching, butterflylike orange and yellow *Persians* flitting across their airy domain.

However, it is in the ceiling installations, called *Pergolas*, that Chihuly has created an actual architecture for the *Persians*, an environment where they can be exploited to their fullest potential. Lit from above and viewed from below, each *Persian* detail appears crisp, each hue sharp. A sweeping area of striated color might have wedged beneath it a tiny, ancient form, while a collection of jumbled vessels can be individually explored in an intimate manner often impossible in the wall installations. In the *Pergolas*, environment becomes a complete sensory experience, enabling the viewer to gain access into a perfect, self-contained, other world, a garden of light, color, and line. Chihuly's dramatic installations, with their opulent combination of colors and textures, hint at the lavish spectacles and sumptuous pageants so adored by the Byzantines and the Venetians. A primary function of pageantry and ceremonial architecture is to move its participants from one, everyday world into another, marvelous or sublime, one. Western medieval architects effected the transformation of their sacred environments with acres of stained glass and soaring spires. For Muslim architects, the stalactitelike formations of muqarnas were the key to the metamorphosis of interior space. Breaking up the light and space on ceilings, domes, and in corners, muqarnas transformed secular space into a beautiful "dome of heaven." Through their dynamic light, color, and line, the *Persian Pergolas*, too, transform everyday space into a paradisaic environment of wonder.

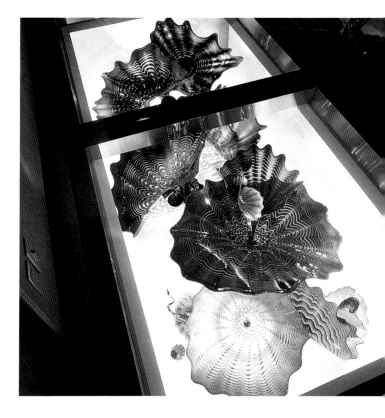

Yasui Konpira-gu Shinto Shrine,
Kyoto, Japan, 32 x 57 x 132 in., 1991.

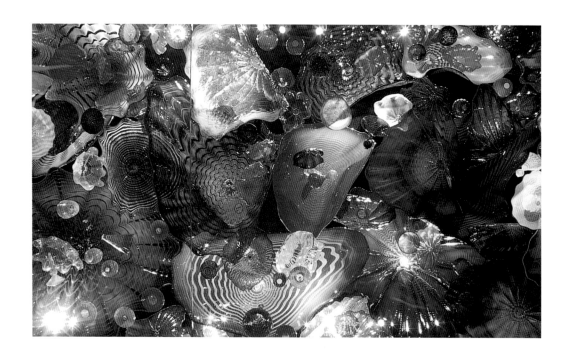

THE GARDEN OF HEAVEN AND THE PLEASURE DOME

Reflecting on what is Persian about Chihuly's *Persians,* certain themes emerge, such as the historical and cultural references or the stylistic similarities with ancient, Islamic, and art nouveau glasses discussed earlier in this essay. There are other quintessential Persian ideas, however, that can be explored in the context of the *Persians.* These are the related concepts of the Persian garden and the Persian carpet.

In Islam, the perfect world, or paradise, is represented by the garden, a place of marvel, wonder, and other physical and spiritual delights. While Chihuly's Persian installations may be linked conceptually with the idea of the Persian garden of paradise, the most direct, visual comparison for the installations may be the Persian carpet.

Carpets are known to have been made in Persia at least since the time of the first Achaemenid ruler, Cyrus the Great. Legend has it that his tomb was covered with the precious textiles.

The influence of textiles crops up repeatedly in Chihuly's work—who began his artistic career as a weaver—and is evident in series such as the *Navajo Blanket Cylinders* or his *Baskets* which enabled the artist to combine an "early interest in weaving with his passion for glassblowing."[39]

Of the many varieties of historic Persian carpets, the most meaningful for this discussion are the medallion-style and garden-style carpets, characterized by their many colors and patterns as well as by the juxtaposition of small and large (medallion) forms. *Persian* installations use a similarly broad but unified palette of color and pattern expressed through an arrangement of various-sized forms, simultaneously appearing ordered and scattered at random.

More thematically related to Chihuly's work, perhaps, are the historic garden carpets. Inspired by the centuries-old Persian love of gardens and their cultivation, these carpets incorporate flowerbeds, paths, fountains, and pools in their designs. The most famous of the carpets was the royal Spring of Khosroe—set with precious stones and pearls—that is said to have adorned the throne room of the 3rd-century Sasanian palace at Ctesiphon, near Baghdad, where it symbolized a paradisaic garden perpetually in flower.[40] Like the garden carpets, the *Persian* installations can represent perpetual gardens of paradise.

While Persian gardens represented the landscape of paradise, it was the pavilions in those gardens, strewn with carpets and adorned with fountains, that represented the architecture of paradise. This important Islamic concept of a paradisaic architecture was also expressed in the plan of the mosque, where the outer courtyard and fountain referred to the garden of paradise, while the mosque itself

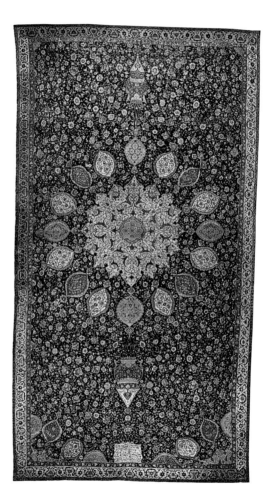

Ardabil Carpet, 23 ft. 11 in. x 13 ft. 5 in., 1540, silk and wool. ©Los Angeles County Museum of Art, Gift of J. Paul Getty

symbolized the dome of heaven.[41]

The *Persian* installations, however, have an additional component: they may be appreciated in two and three dimensions, both as a patterned wall or ceiling "carpet" of color and form and as a three-dimensional "garden" environment, aspects that are especially successful in the *Pergolas*.

In their aesthetic creation of a perfect, other environment outside of everyday experience, the *Persian Pergolas* become like the pleasure domes, creating not only a garden of paradise but an architecture of paradise as well, where earthly beauty reflects the perfection of the heavens above. Through Chihuly's evocation of wonder and his invocation of the marvelous—what the French surrealists called *la merveille*—he succeeds in creating a metaphorical portal to an other consciousness.

PERSIANS

Although the natural beauty of glass is easily exploited, the use of its transformational properties is rarely attempted by artists who work in the medium. Chihuly is a master in the creation of transformational spaces through the construction of an impressive and persuasive mise-en-scene. The sources of his *Persians* are classical Greek, Persian, Byzantine, Islamic, Venetian, and art nouveau, together representing an incredibly fertile palimpsest of ideas and influences. Yet for Chihuly, the *Persians* are only one expression of the underlying, purely abstract and formal objective of his work: the exploration of form and the glass itself as a vehicle for color, and the orchestration of color to create transformational environments. The impetus, however, is the marvelous—*la merveille*—that other, magical world where the source of wonder and delight reside.

CHIHULY PERSIANS

White Persian Set with Scarlet Lip Wraps, 1986.

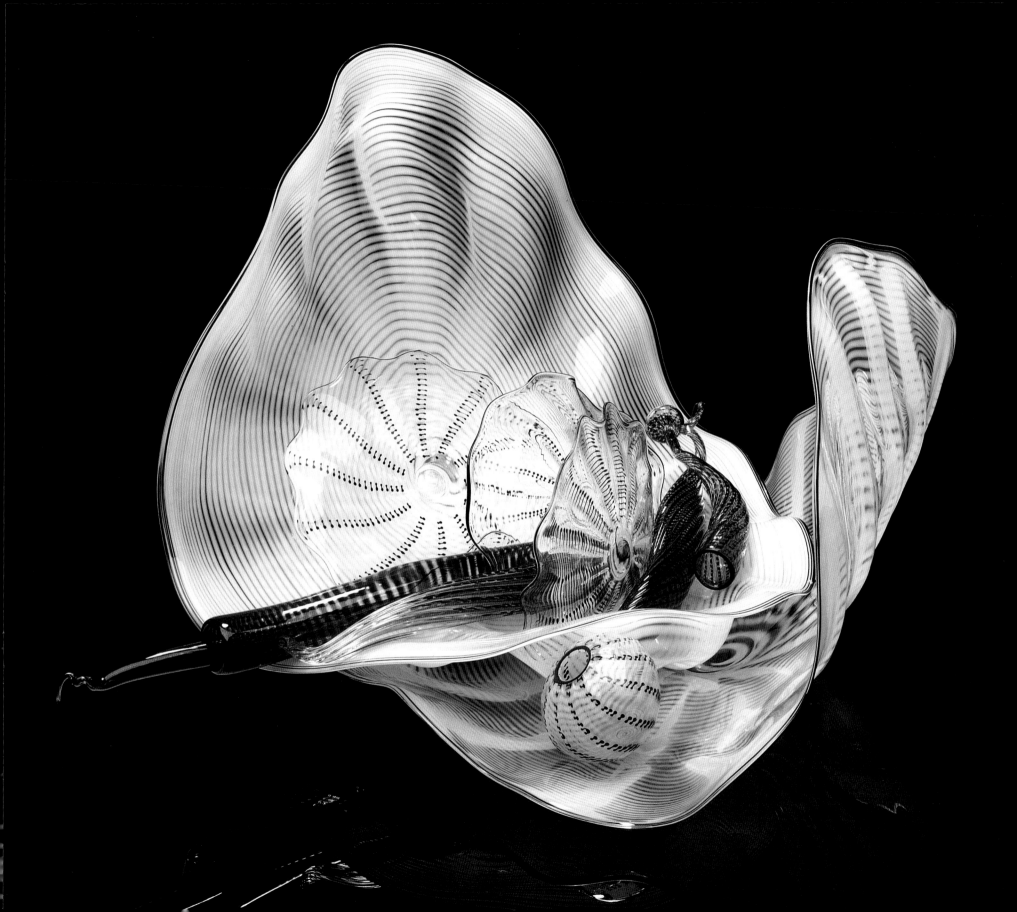

Tortoiseshell Green Persian, 1987.

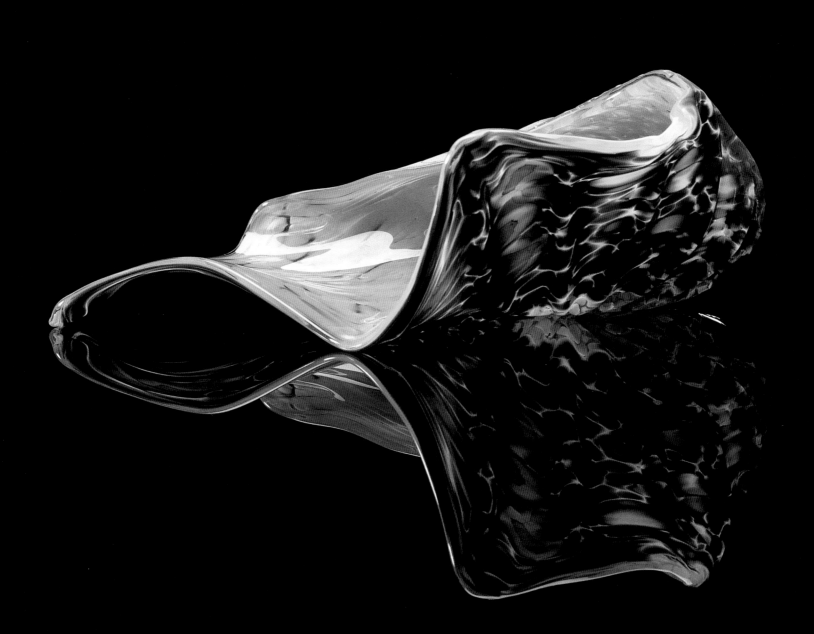

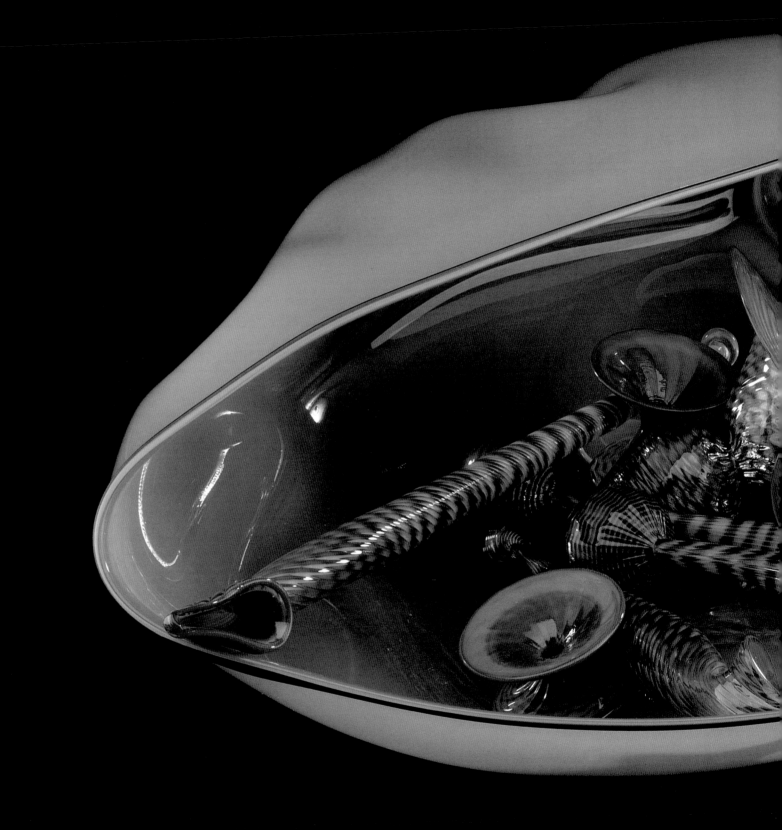

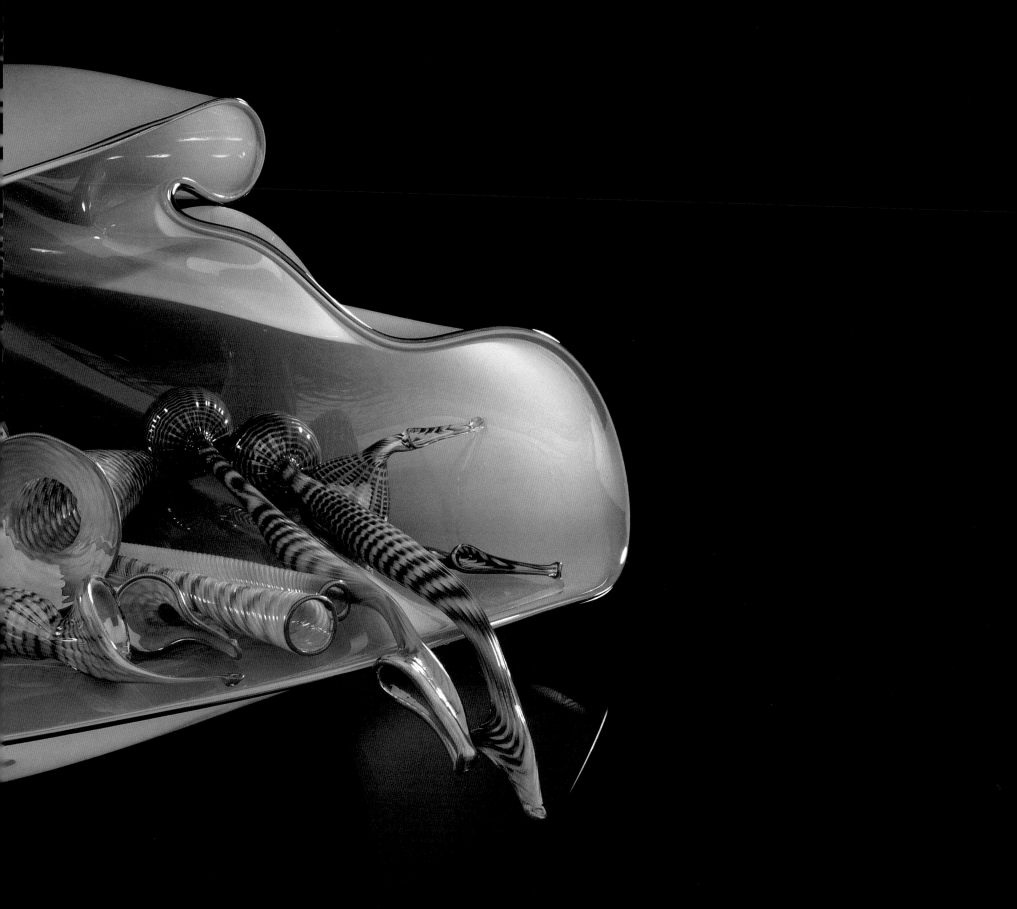

Preceding pages: *Cobalt Green Persian Set with Black and Red Lip Wraps*, 8 x 17 x 22 in., 1987.

Vermillion and Royal Blue Persian Set, 11 x 22 x 20 in., 1988.

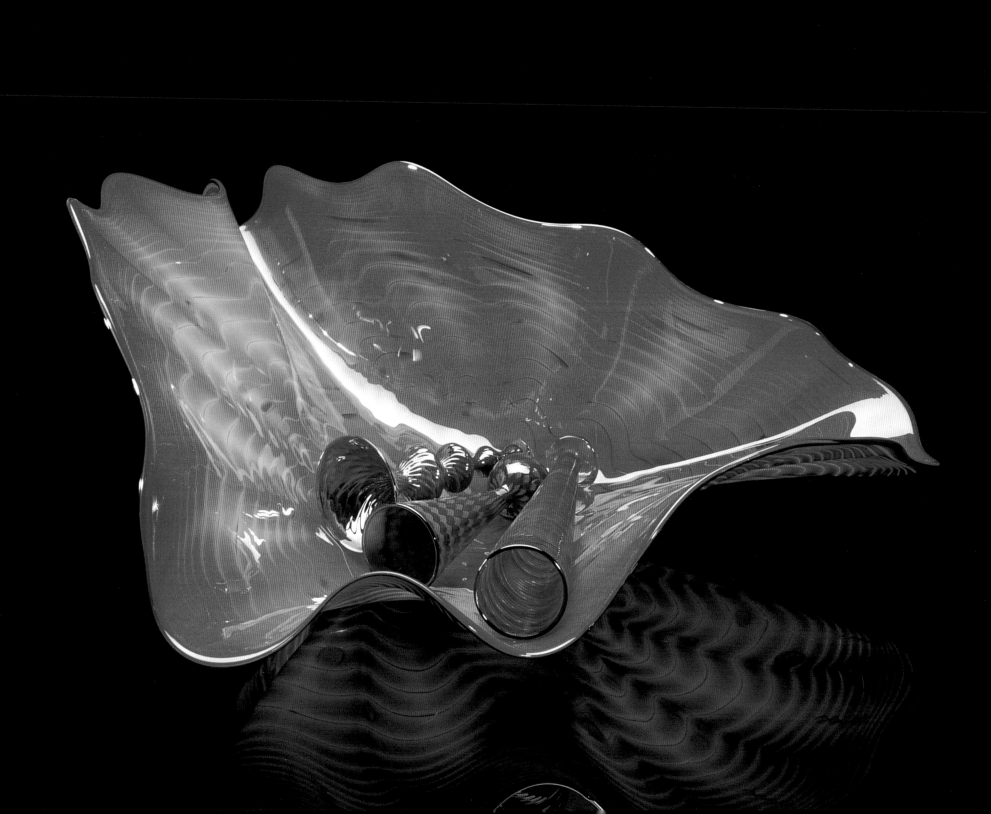

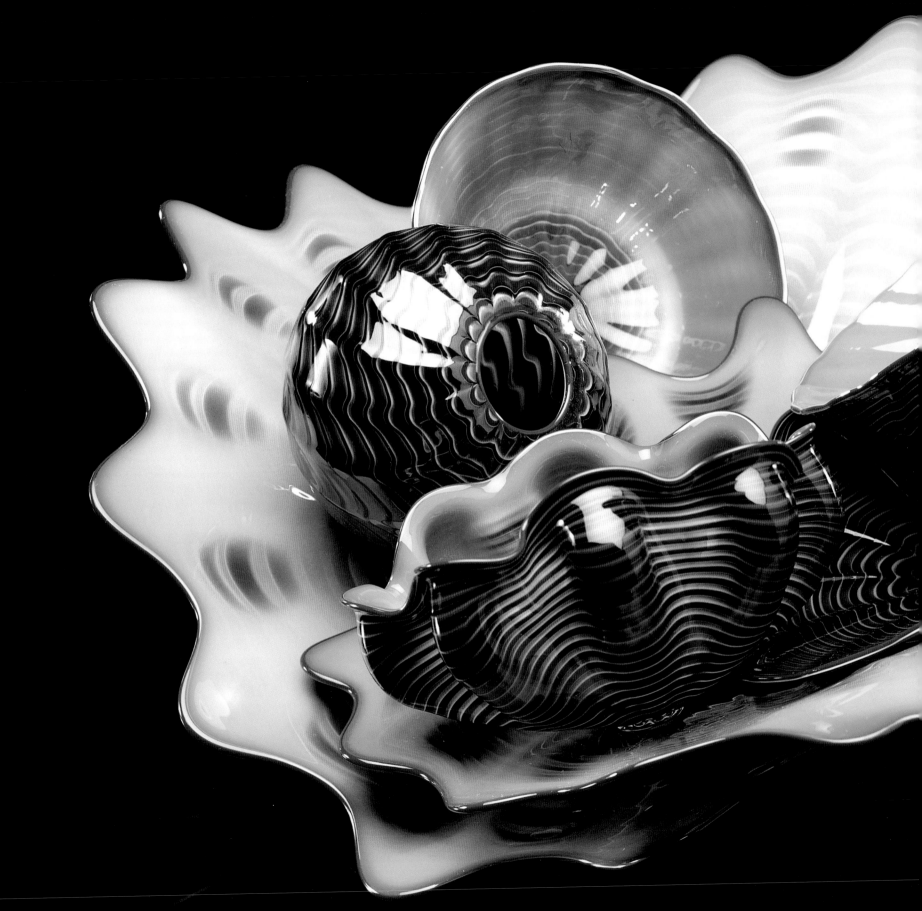

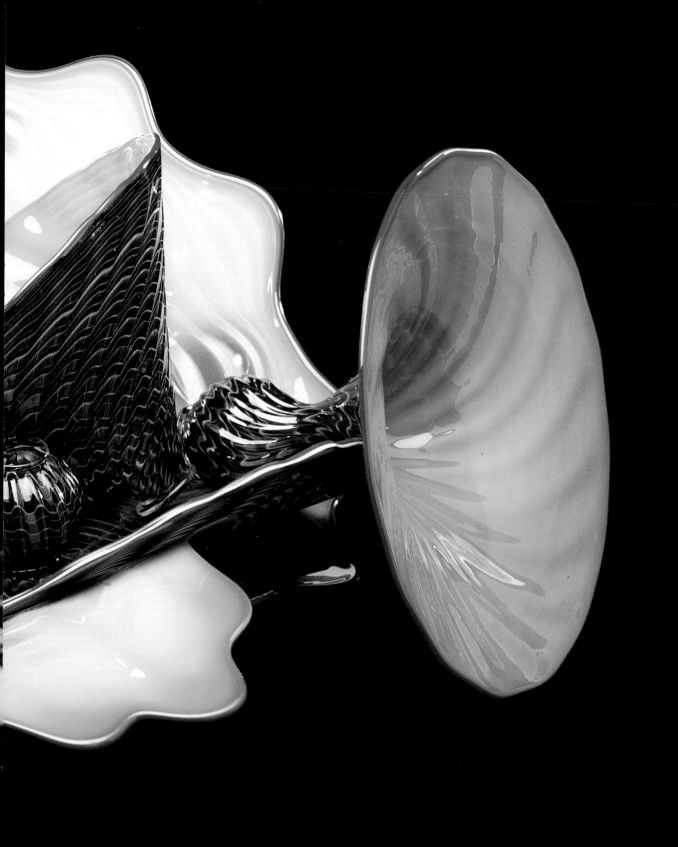

Preceding pages: *Light Green Persian Set with Cobalt Lip Wraps*,

8 x 20 x 17 in., 1990.

Confetti Persian Set, 15 x 27 x 32 in., 1990.

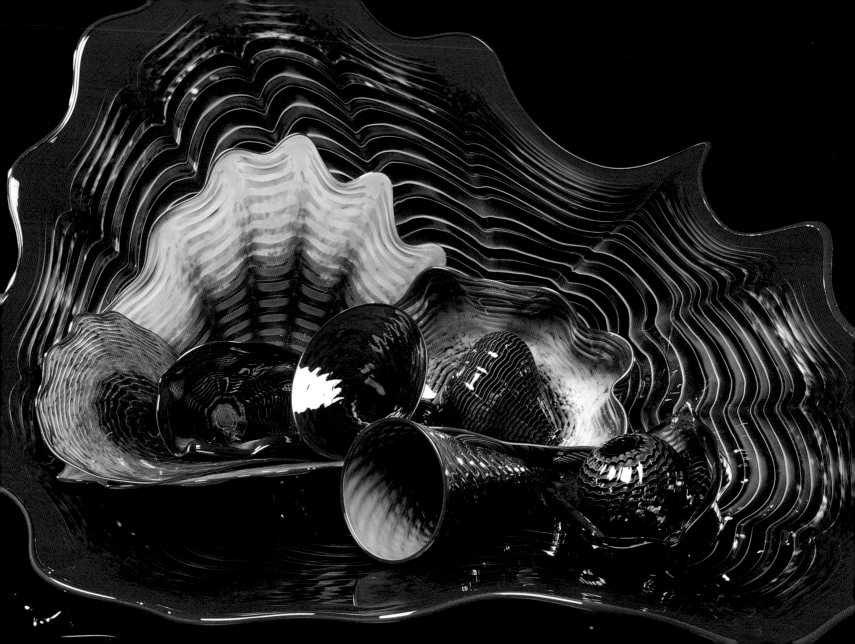

Preceding pages: *Persian Drawings*, 22 x 30 in., 1989.

Light Rose Persian Set with White Lip Wraps, 5 x 18 x 20 in., 1990.

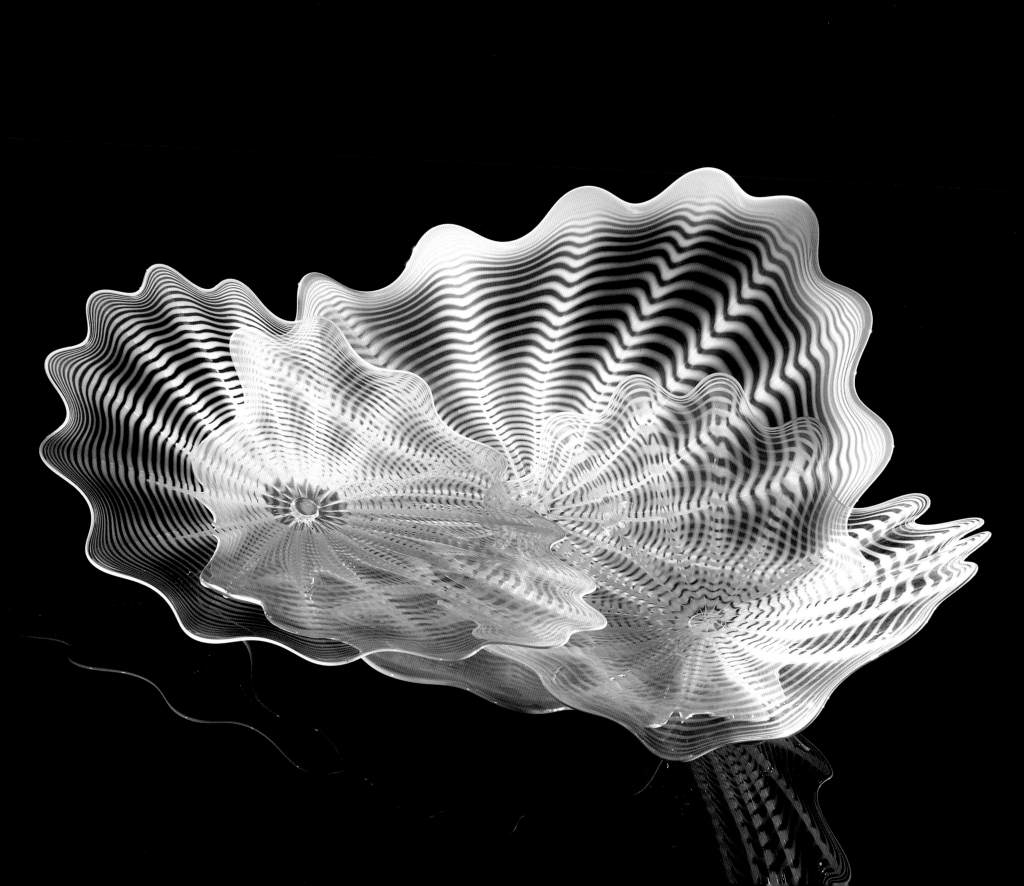

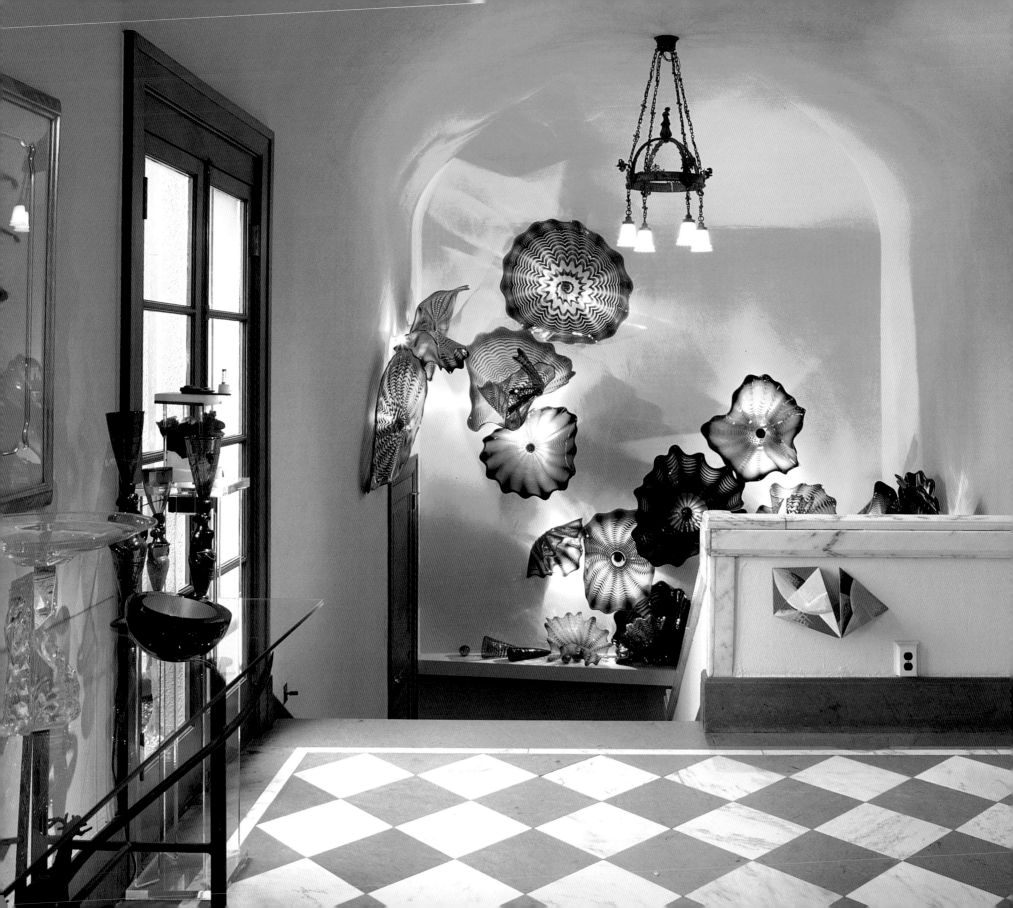

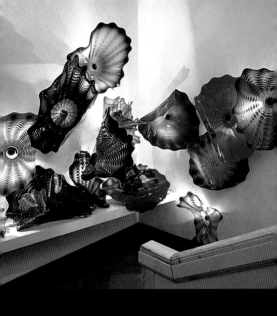

Suzanne and Norman Cohn Installation, 1989, is one of

many *Persian* wall installations designed for a private residence

Burnt Sienna Persian with Blue Lip Wrap, 13 x 24 x 16 in., 1991.

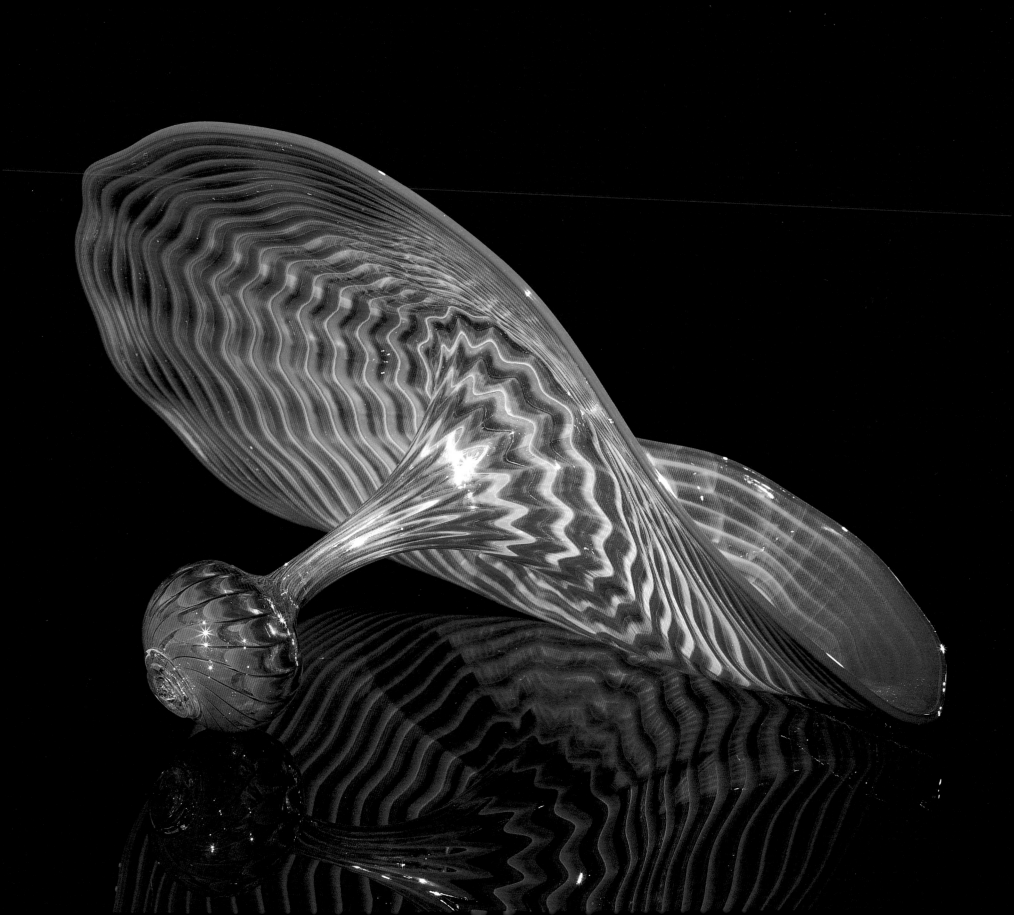

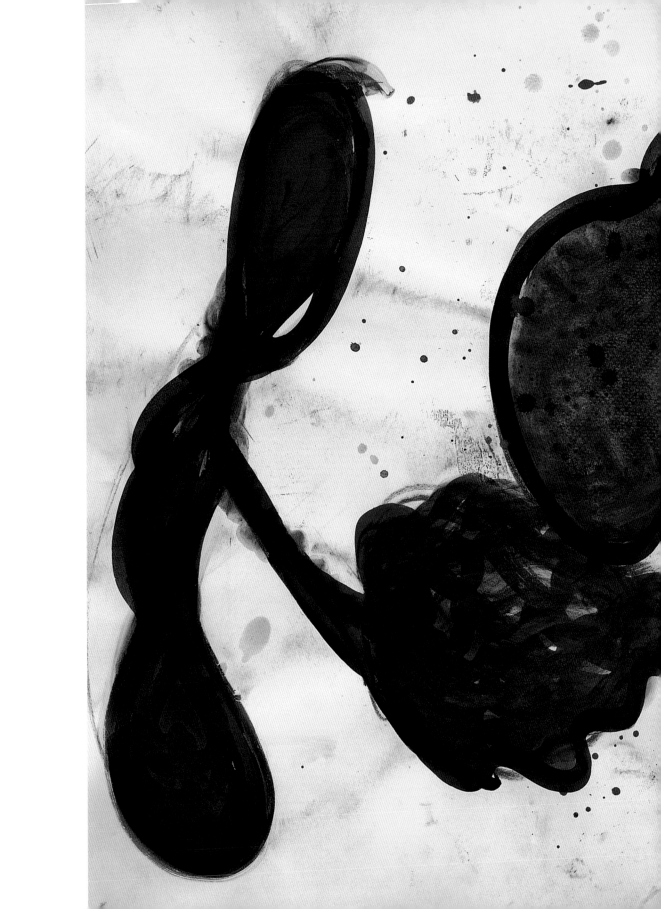

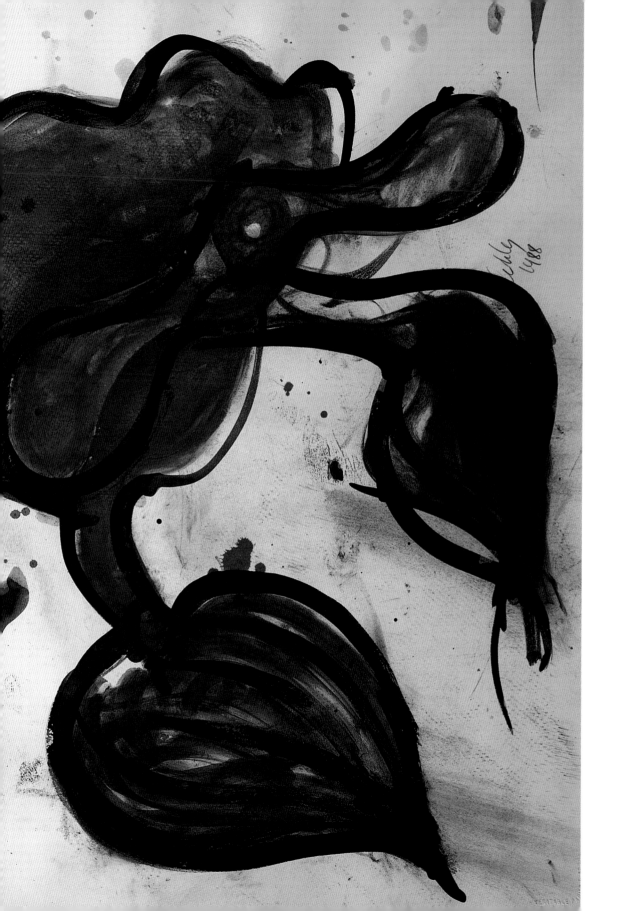

Leaf Form Drawing, 30 x 22 in., 1988.

Following pages: *Verditer Blue Persian Set with Yellow Lip Wraps*, 11 x 20 x 18 in., 1989.

45

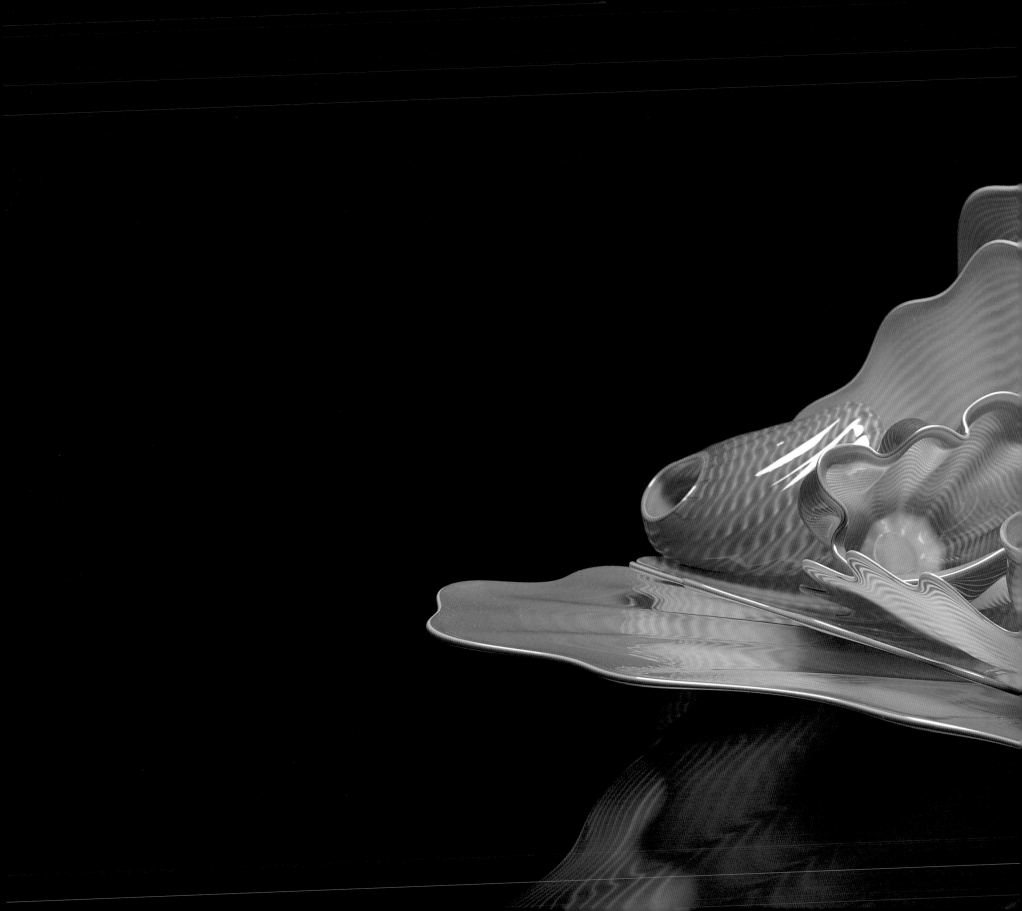

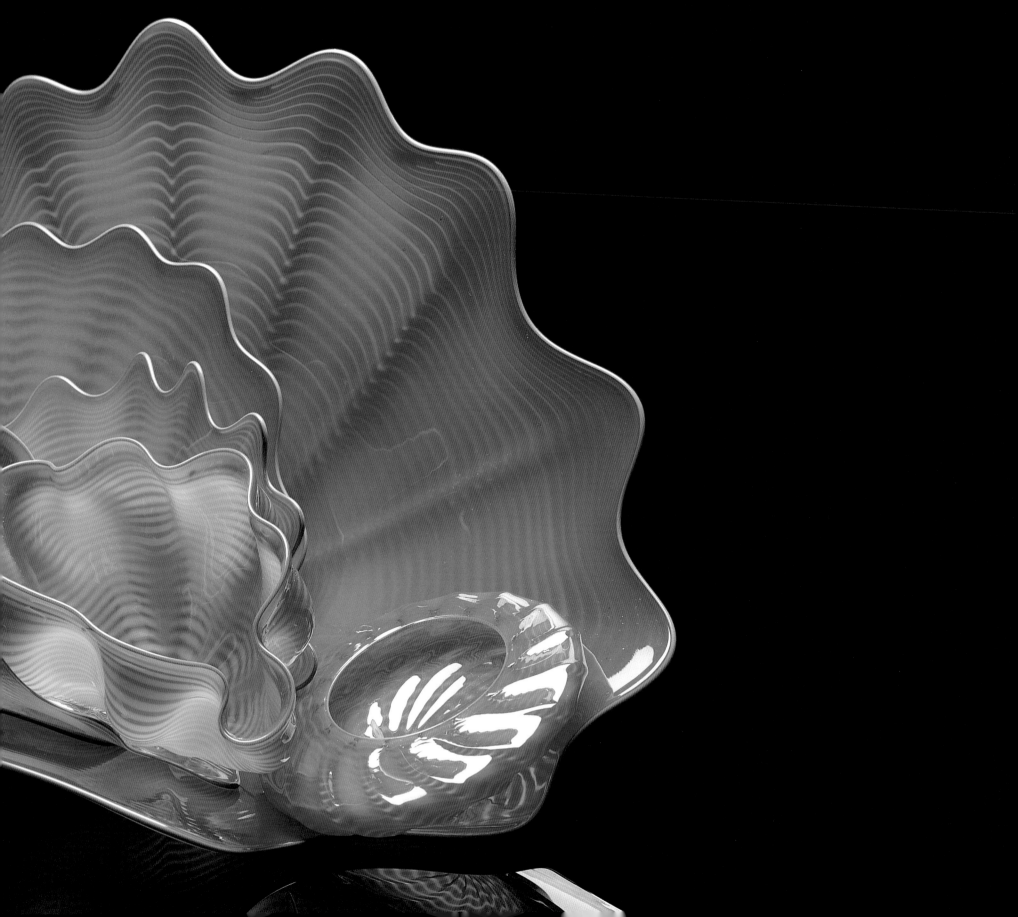

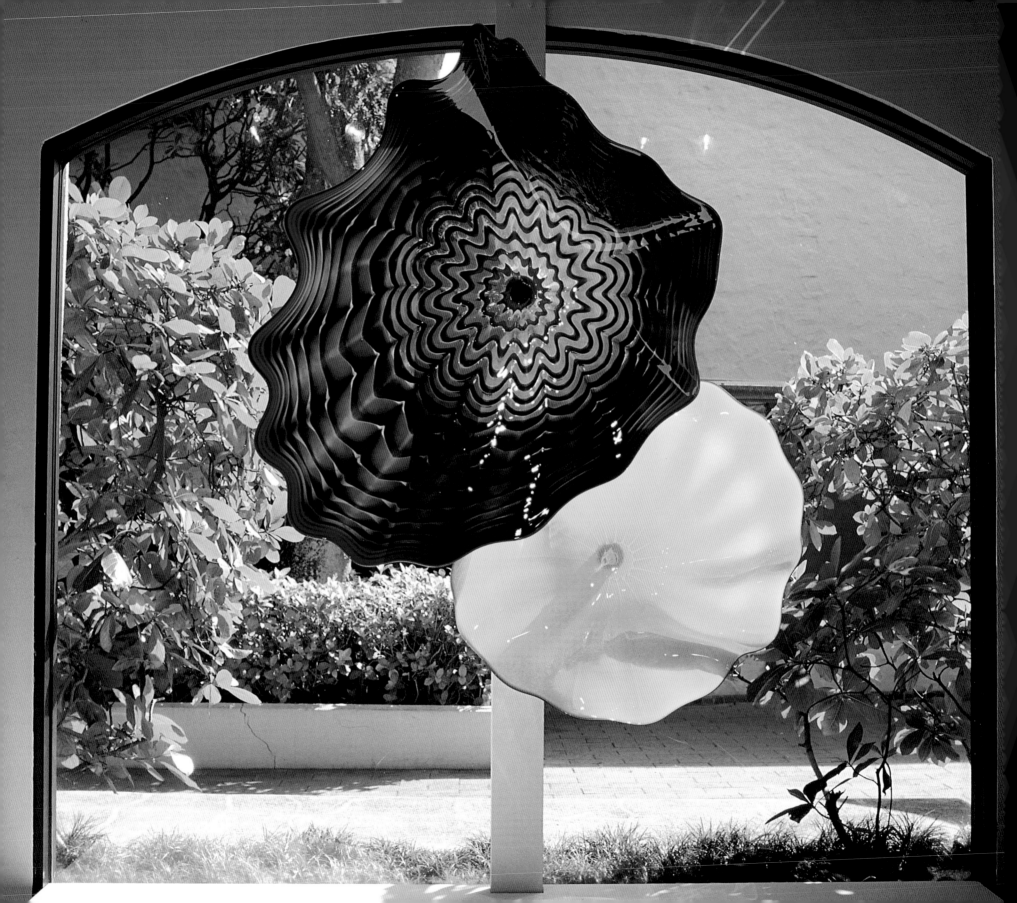

Persian Window, and detail, Honolulu Academy of the Arts, 1992.

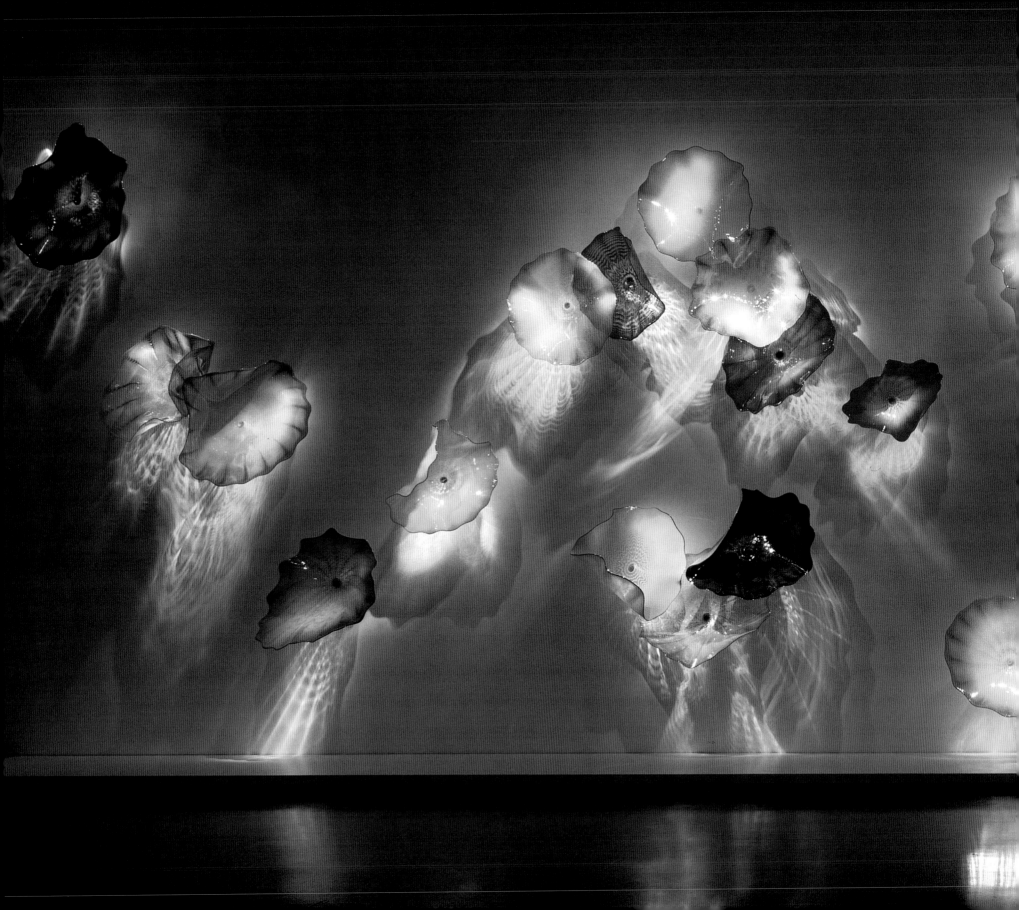

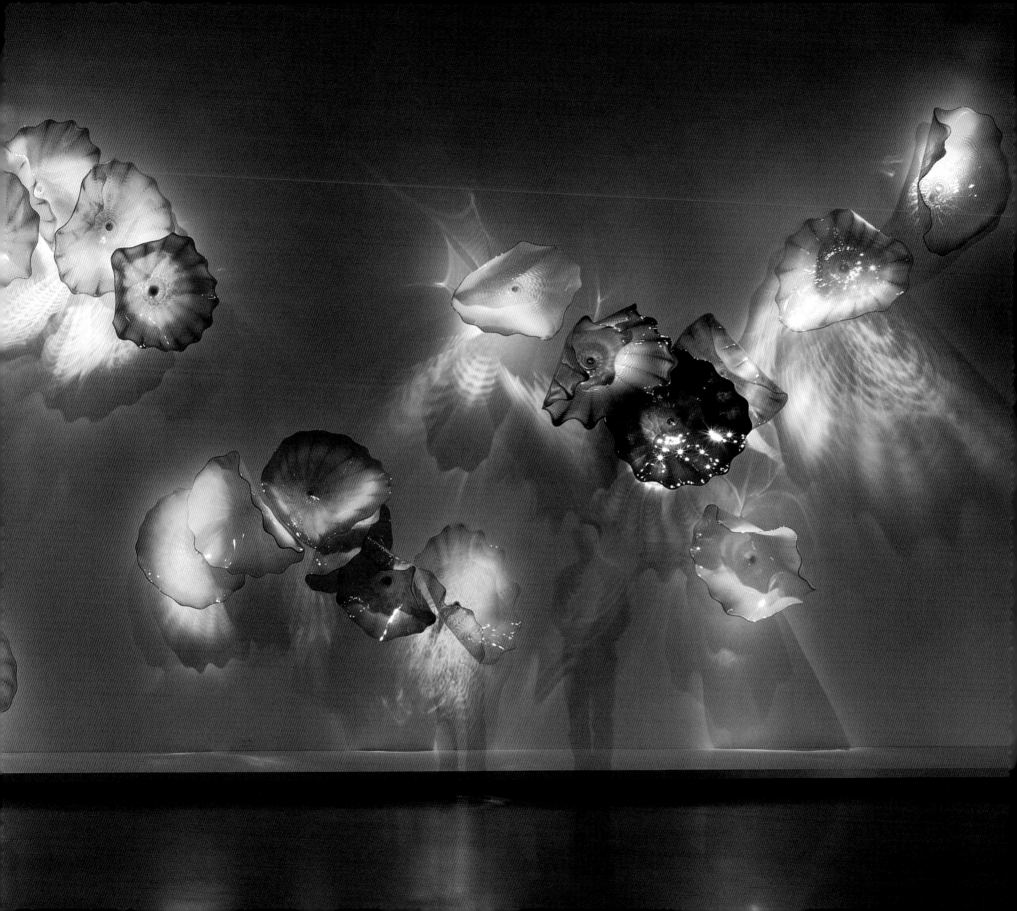

Preceding pages: *Brooklyn Museum Installation*,

New York, 1994.

Yellow Persian Set with Cobalt Lip Wraps, 8 x 25 x 12 in., 1992.

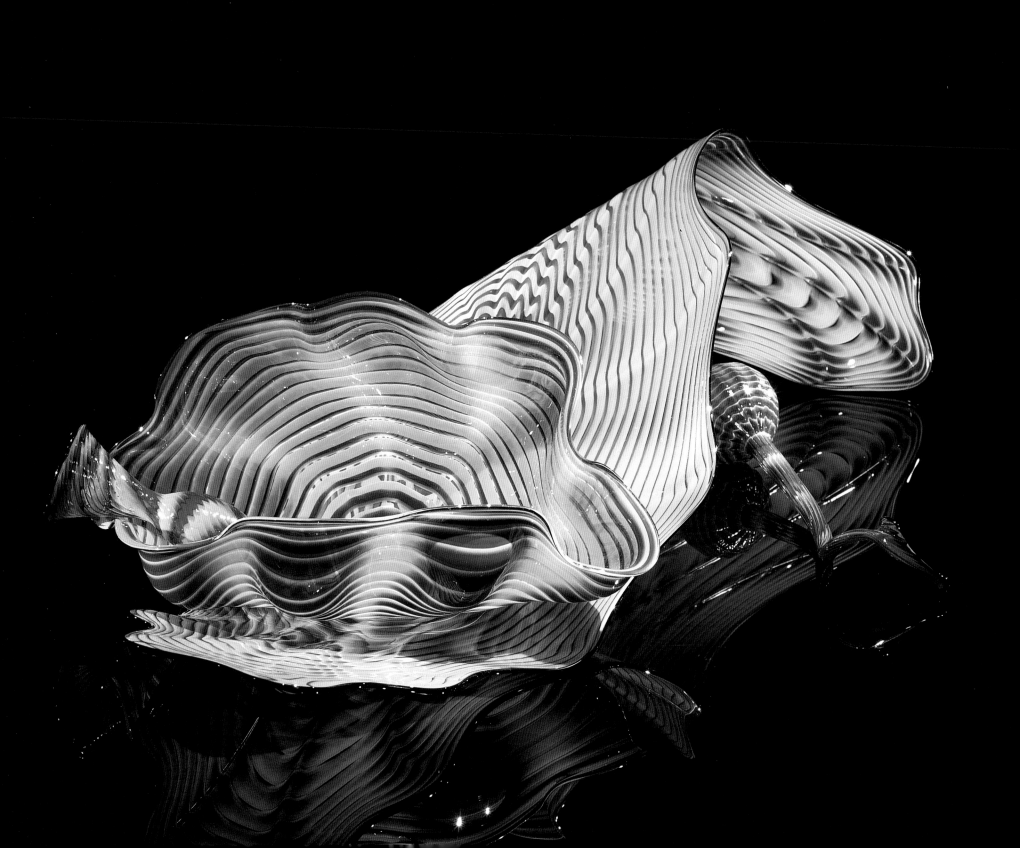

Oxblood Persian with Black Lip Wrap #2, 7 x 14 x 13 in., 1987.

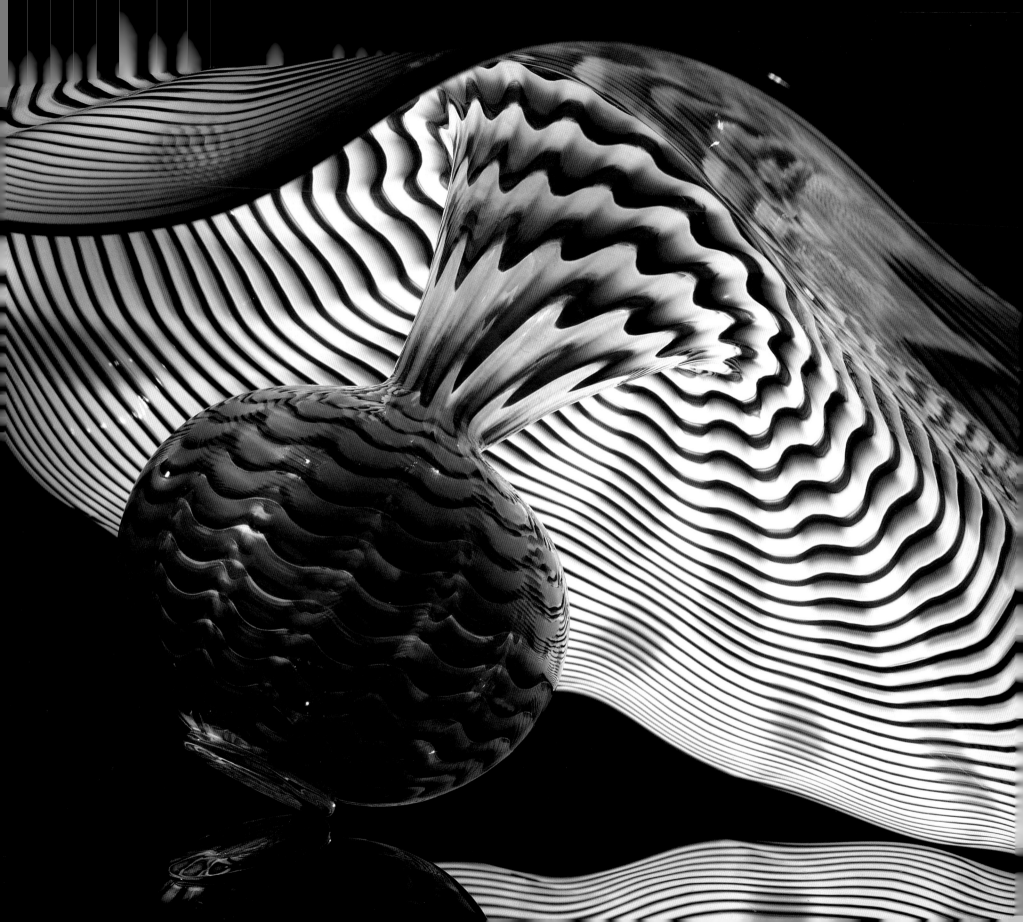

Persian Glass Window, Singapore Art Museum, Singapore, 1995.

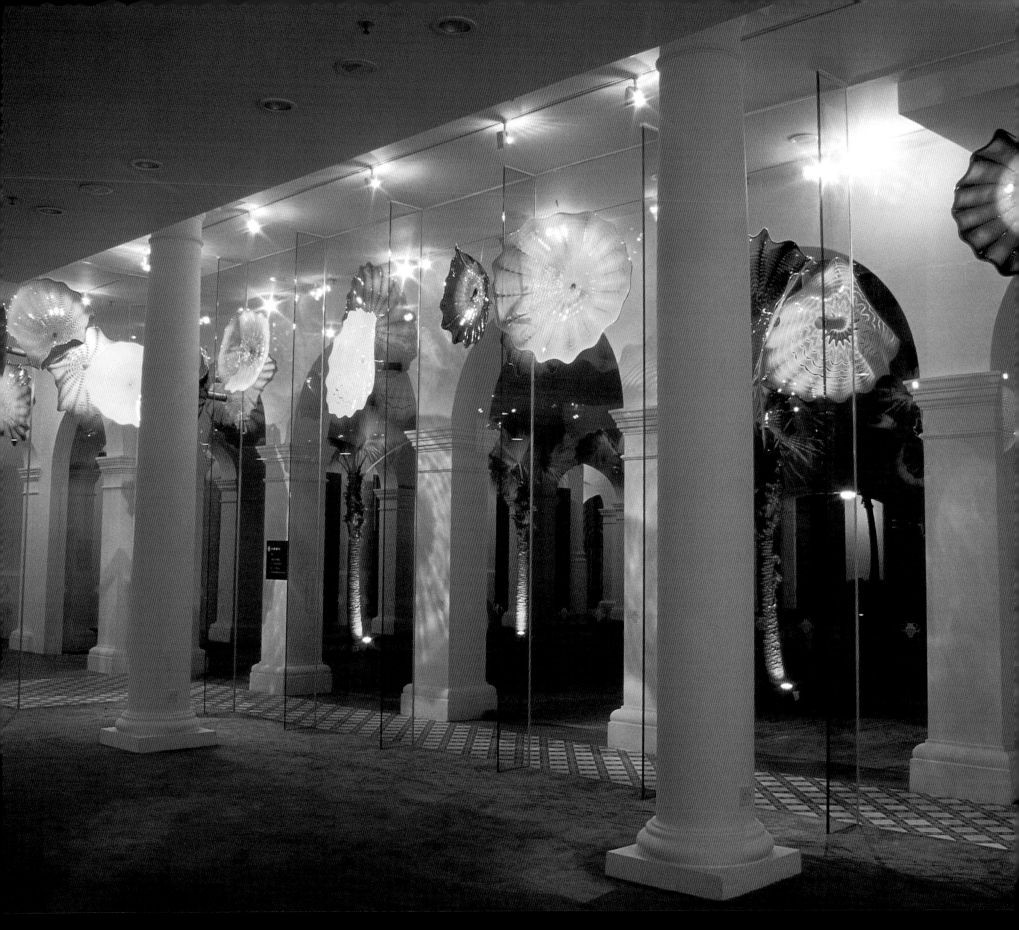

Paris Blue Persian with Cadmium Red Lip Wrap,

13 x 20 x 22 in., 1992.

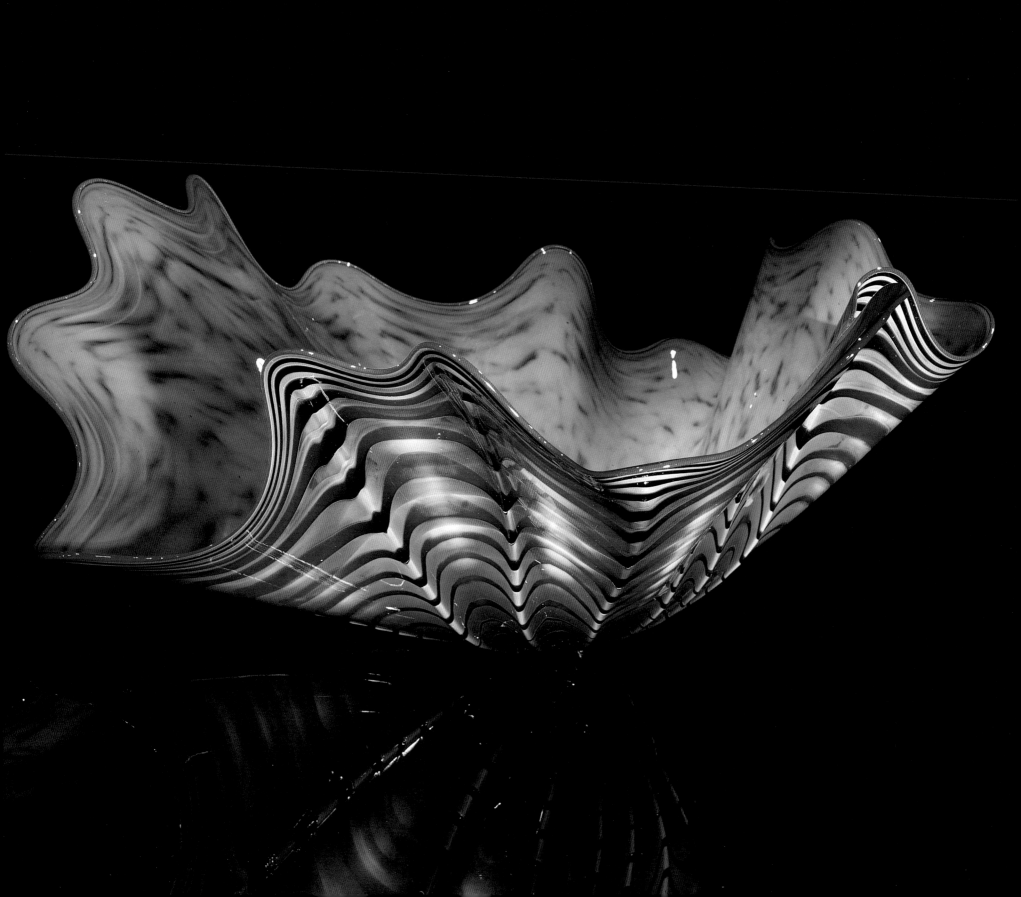

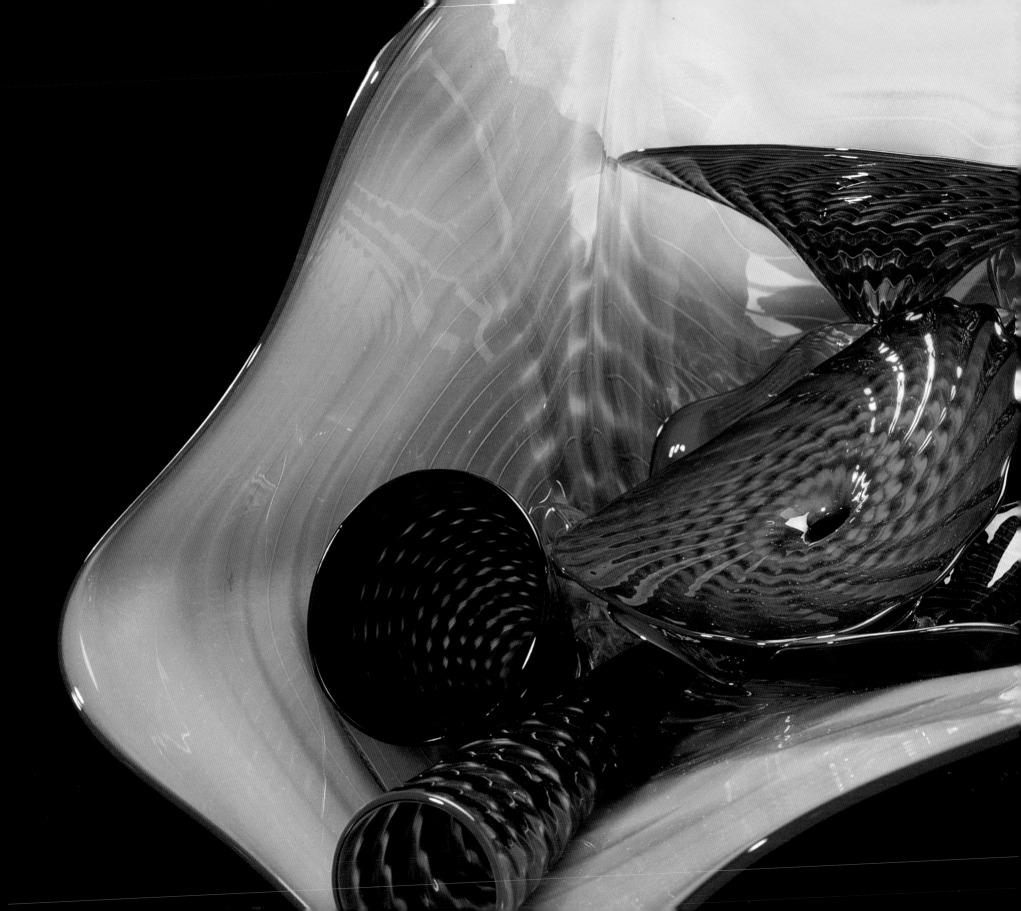

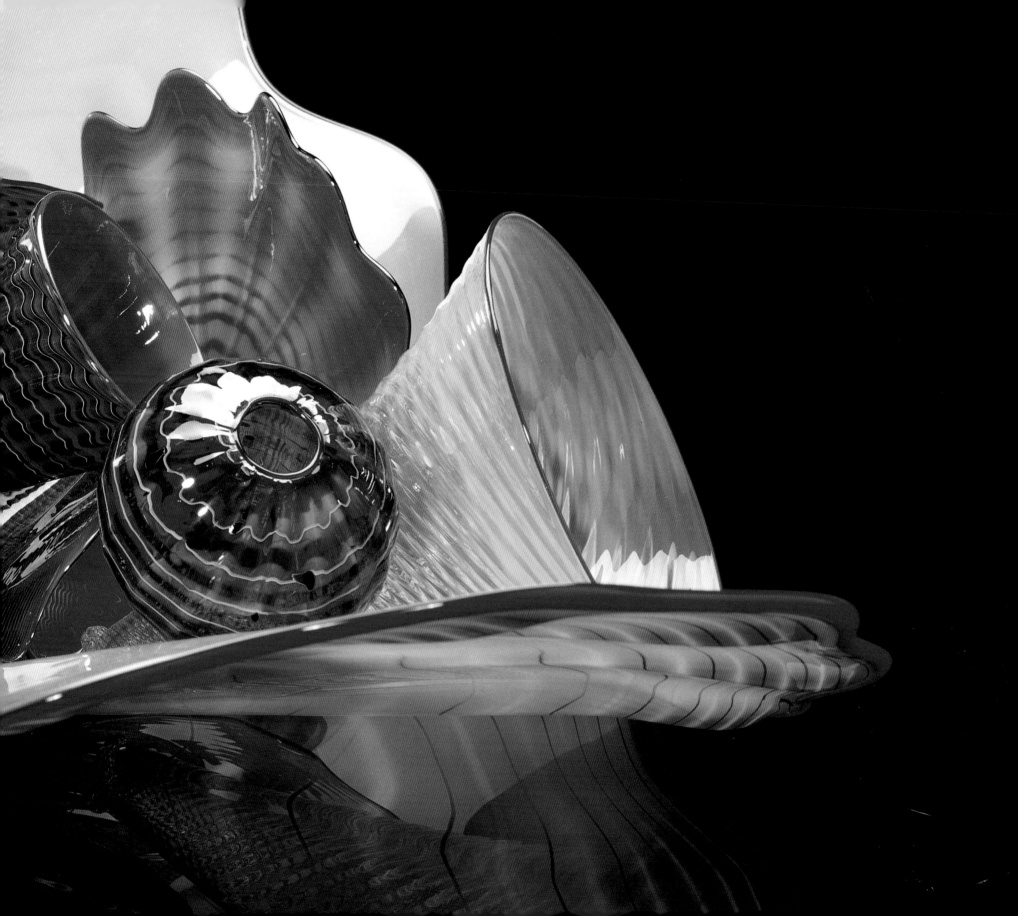

Preceding pages: *Confetti Persian Set with Red Lip Wraps*,

13 x 20 x 29 in., 1992.

Leaf Green Persian Set with Orange Lip Wraps,

21 x 23 x 22 in., 1992.

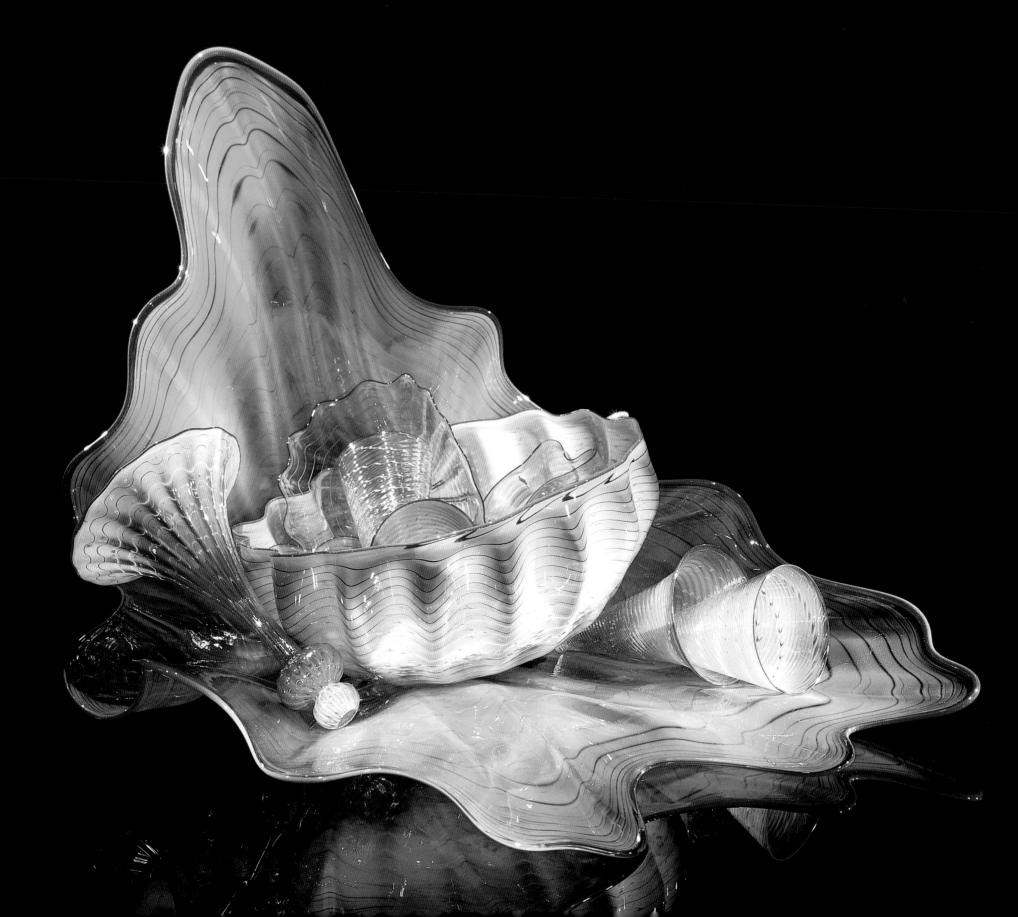

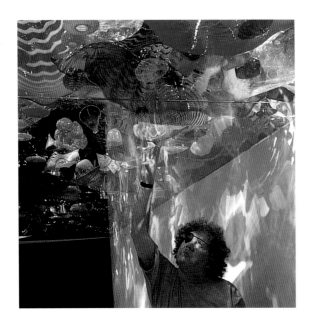

Above: Chihuly under *Persian Pergola*, Detroit Institute
of Arts, 1993.

Persian Pergola, Saint Louis Art Museum, 1996.

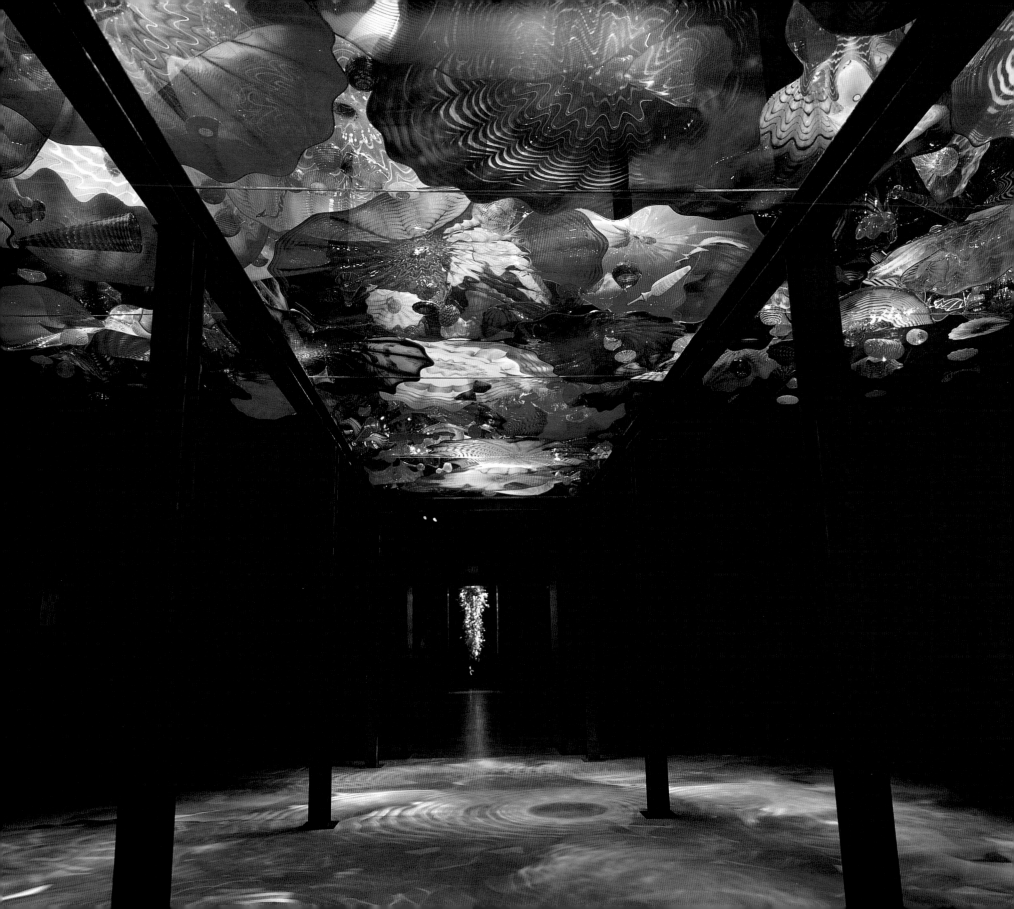

Purple and Pink Persian with Process Yellow Lip Wrap,

13 x 23 x 18 in., 1992.

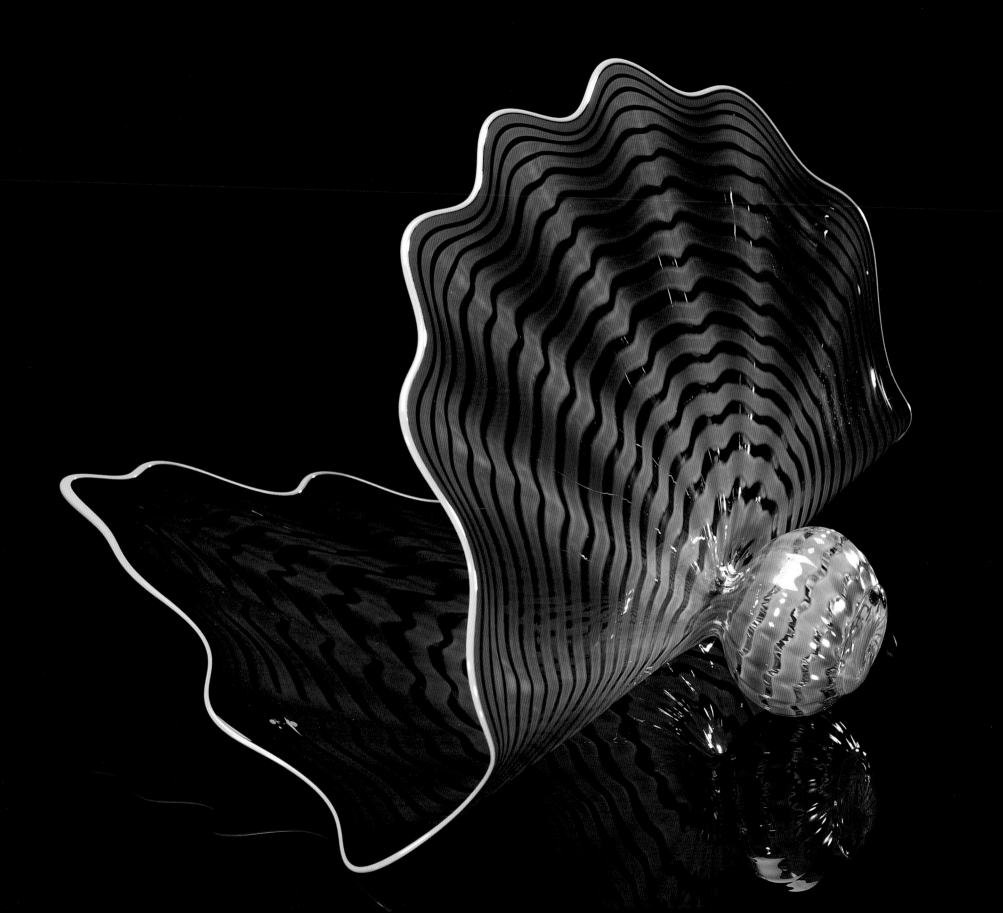

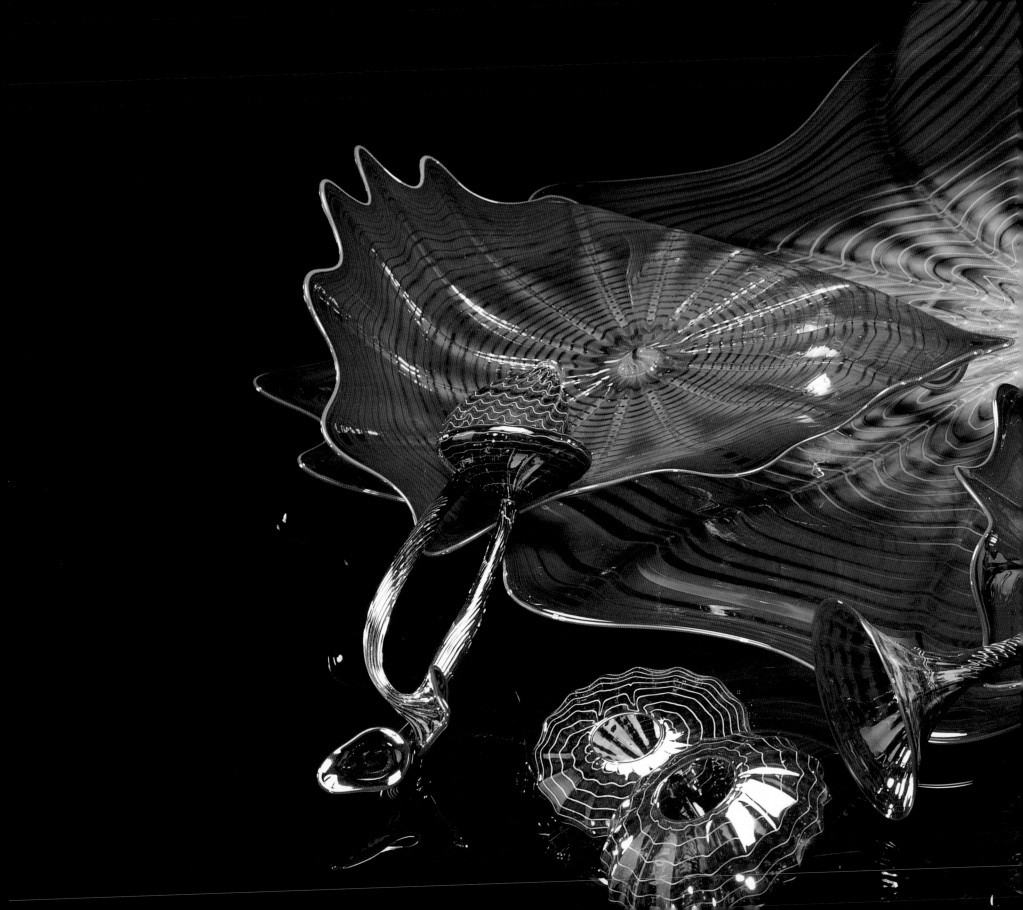

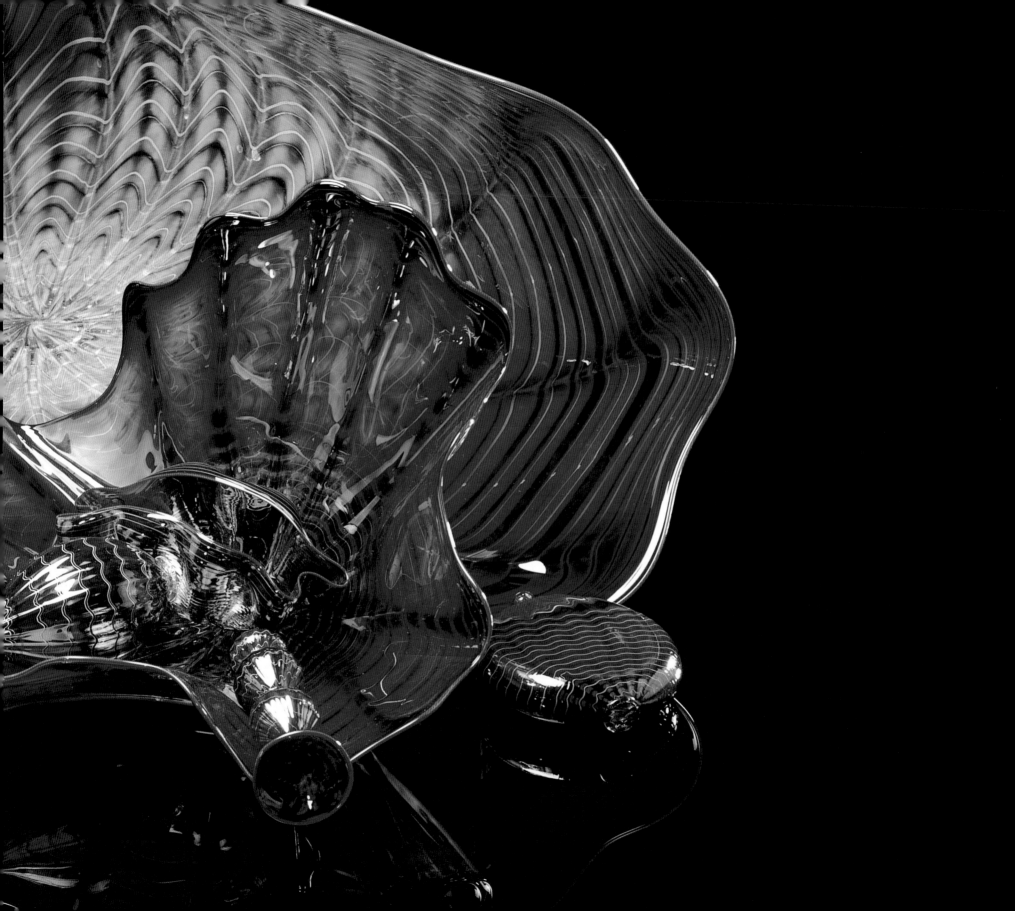

Preceding pages: *Cobalt Persian Set with Red Lip Wraps*,

16 x 45 x 32 in., 1994.

Ice White Persian Set with Obsidian Lip Wraps,

12 x 20 x 13 in., 1994.

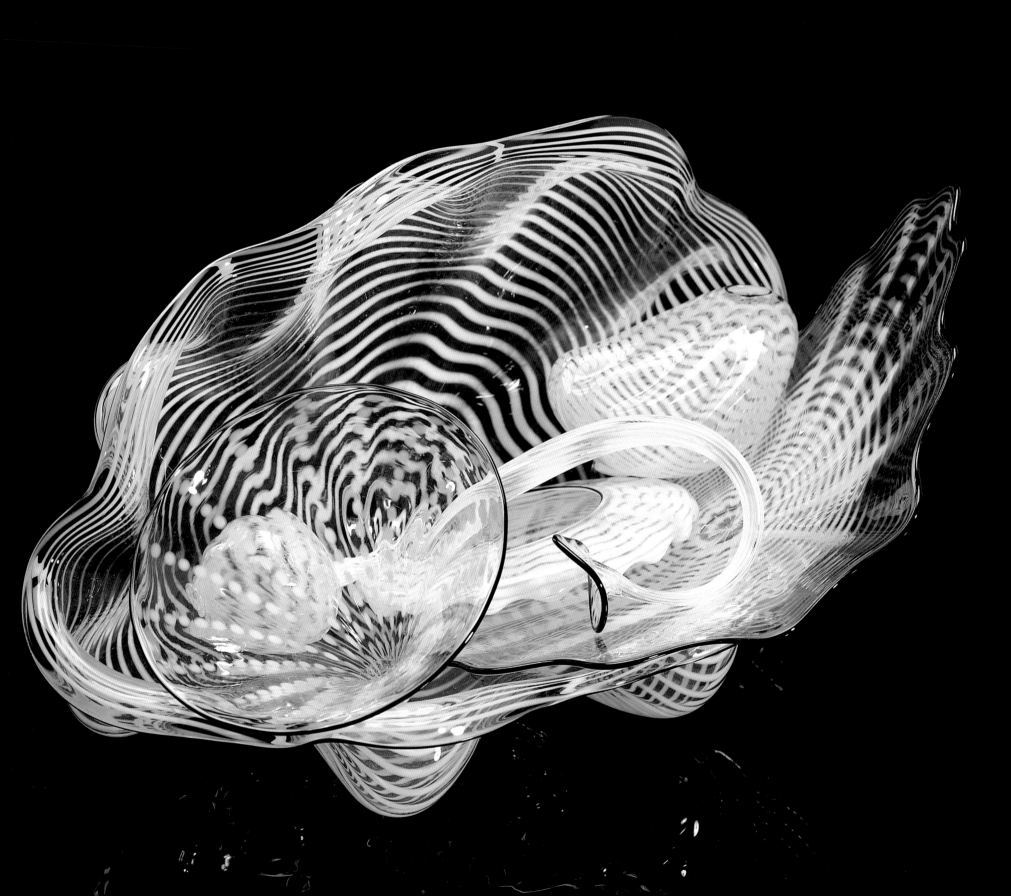

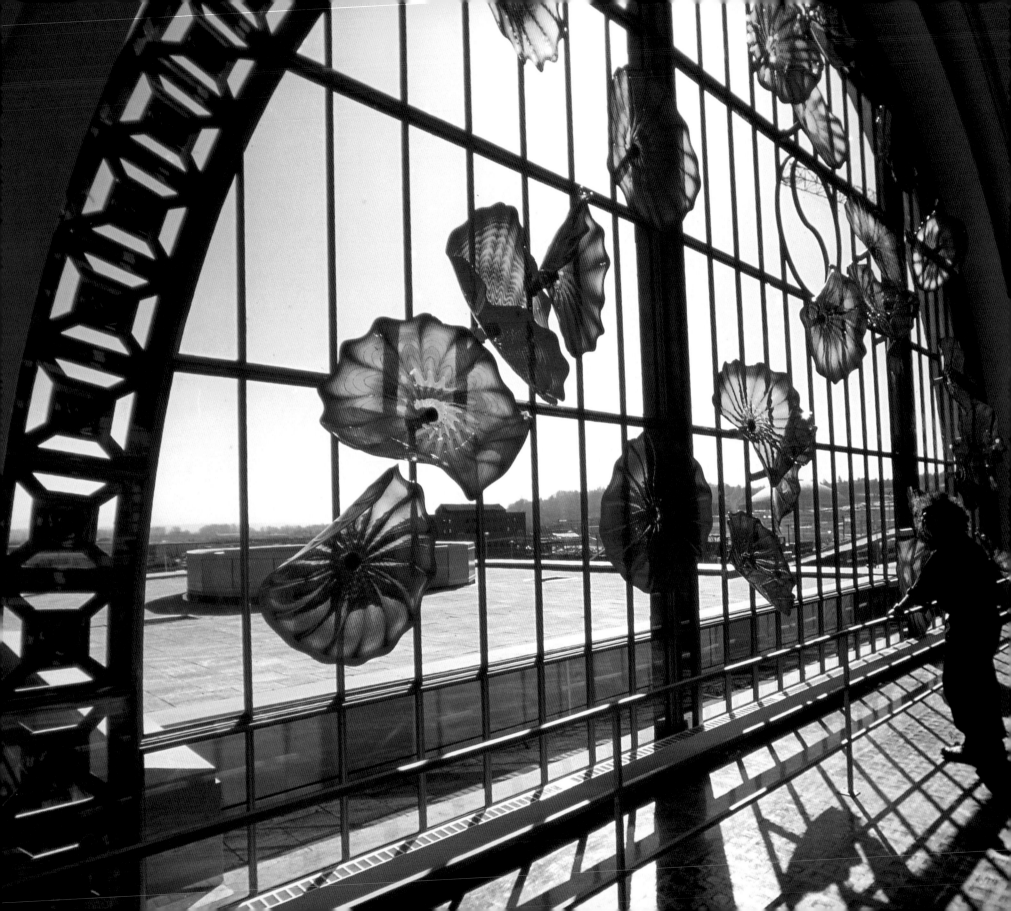

Monarch Window, Union Station, Tacoma, Washington, 1994.

California Poppy Persian Set with Blue Lip Wraps, 1995.

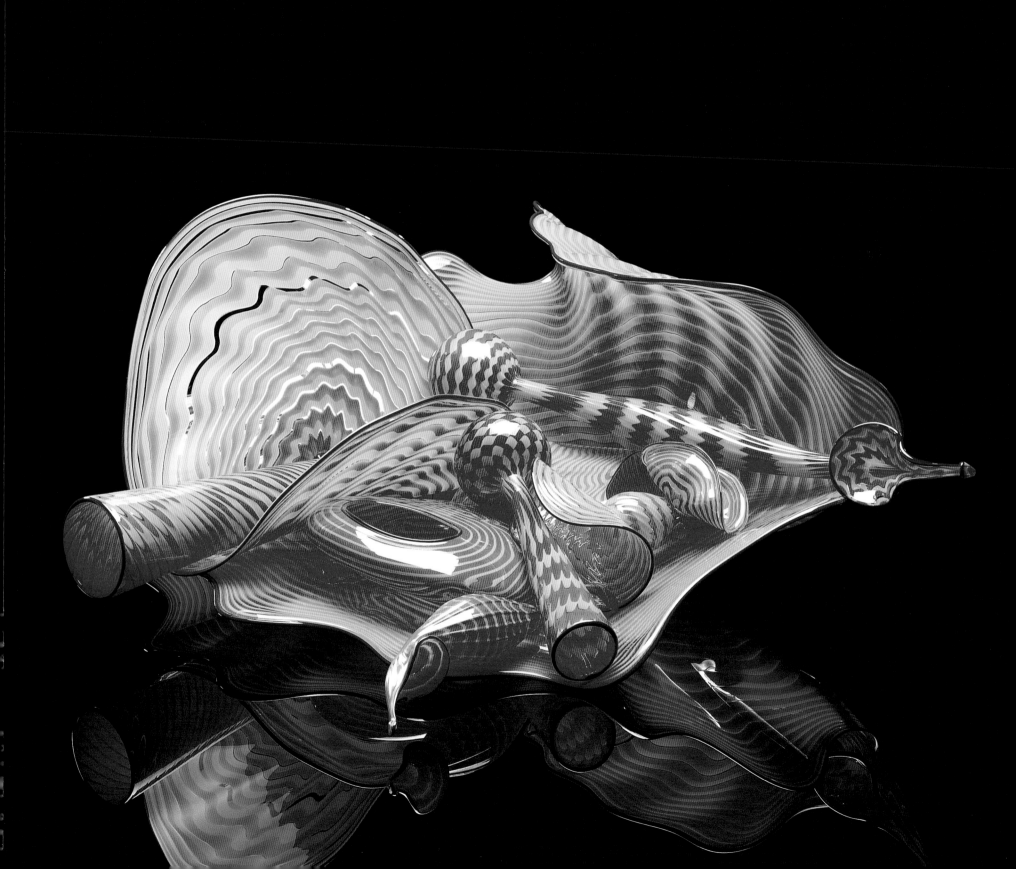

Violet Gray Persian Set with Indian Yellow Lip Wraps,

16 x 16 x 18 in., 1992.

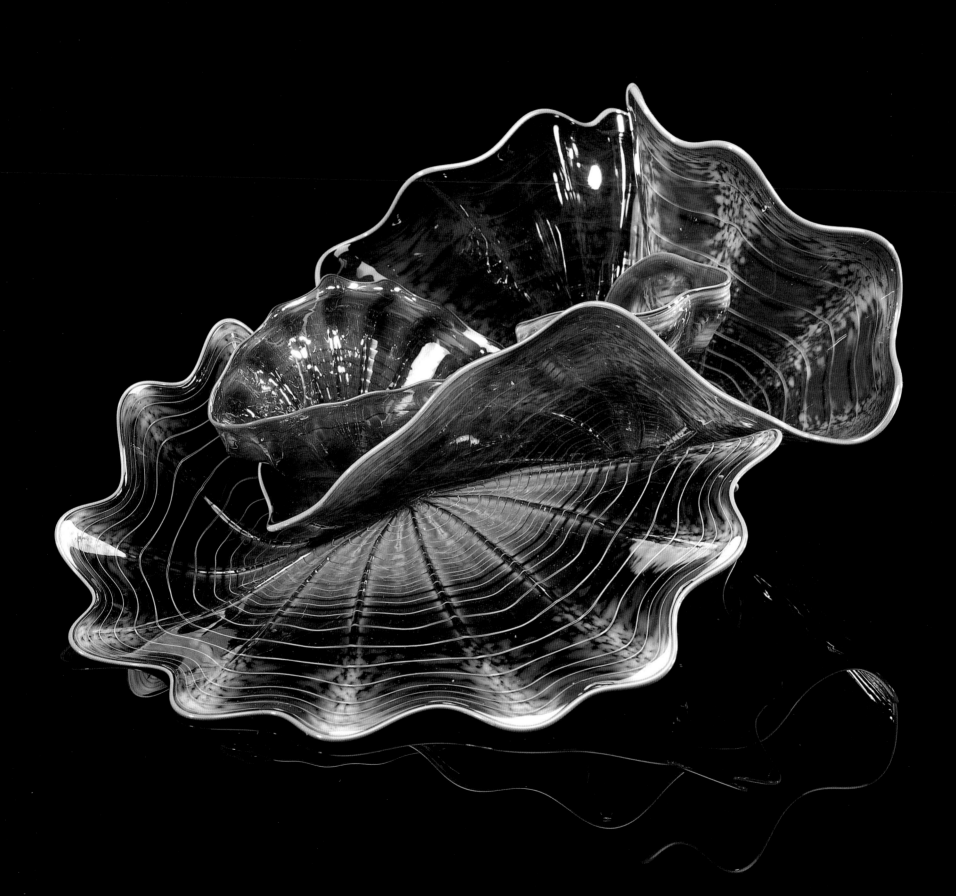

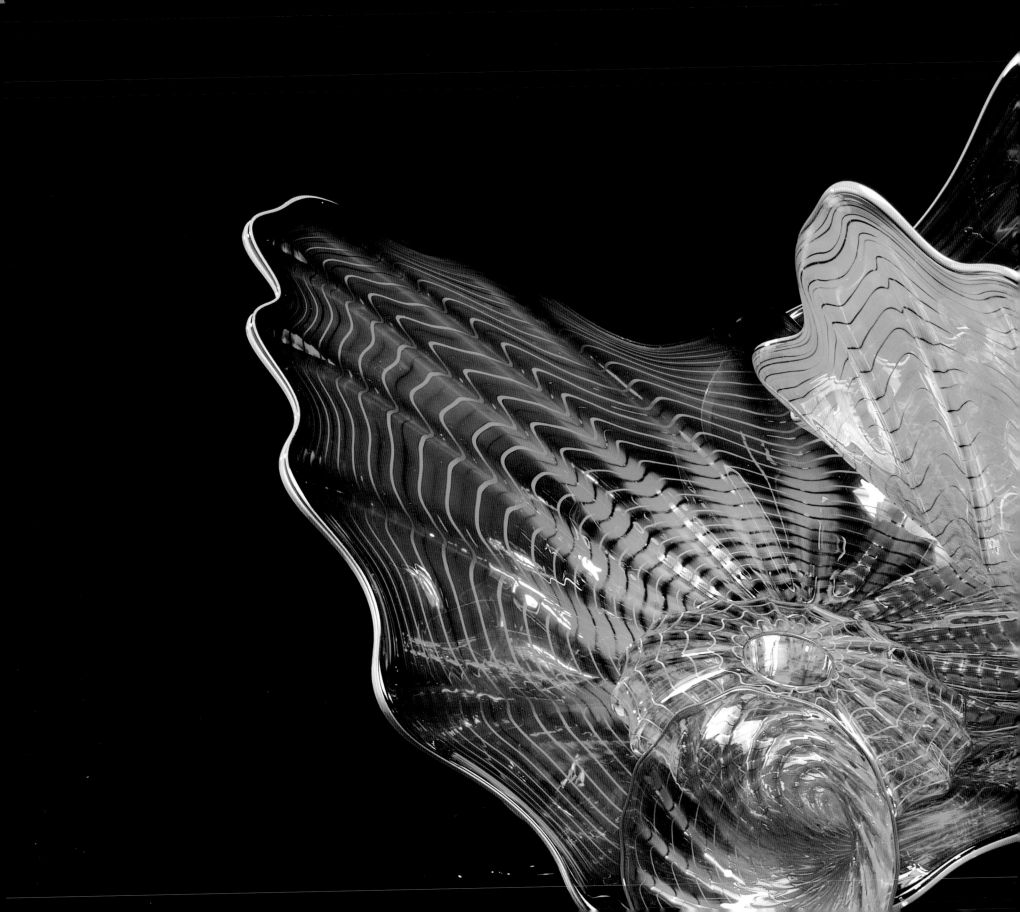

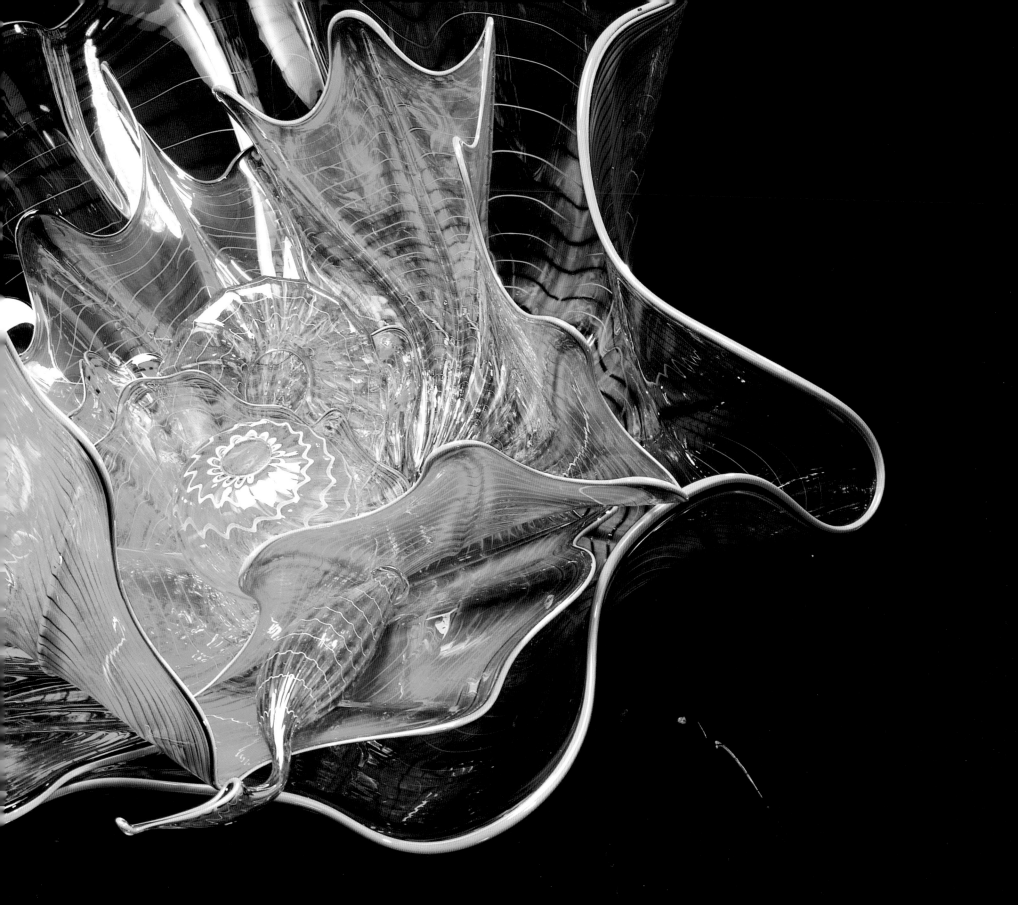

Preceding pages: *Green Blue Persian Set with Orange-Yellow Lip*

Wraps, 20 x 34 x 25 in., 1994.

Royal Yellow Persian Set with Black Lip Wraps,

12 x 18 x 12 in., 1995.

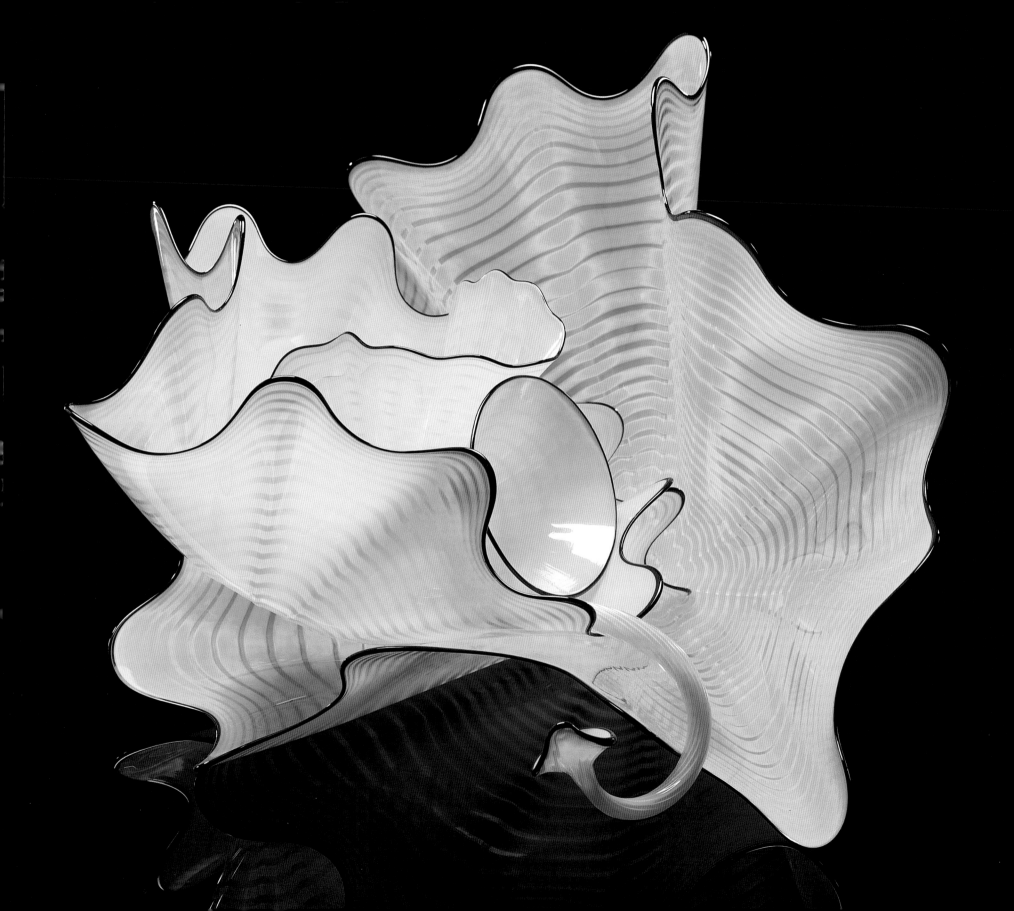

Hart Window, Dallas Museum of Art, 1995. This installation was
commissioned by the art patrons Linda and Mitch Hart.

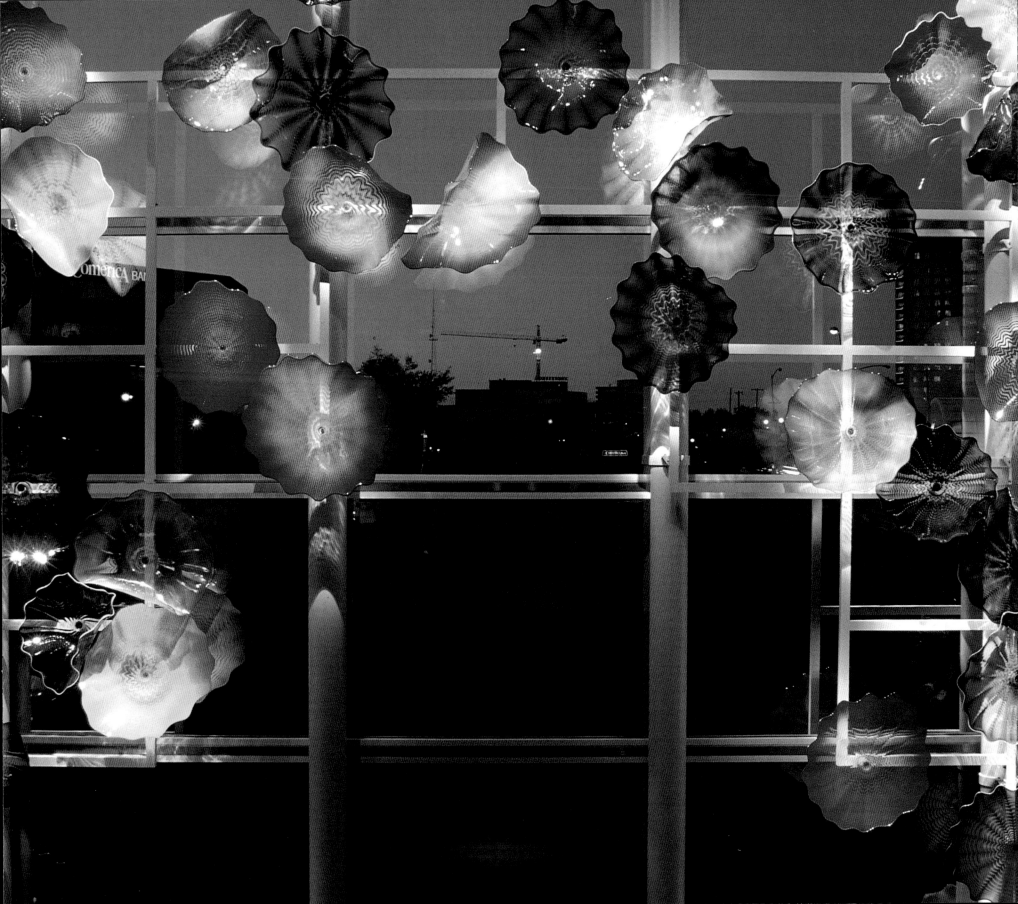

Carmine Red Persian Set with Cobalt Lip Wraps,

16 x 25 x 25 in., 1996.

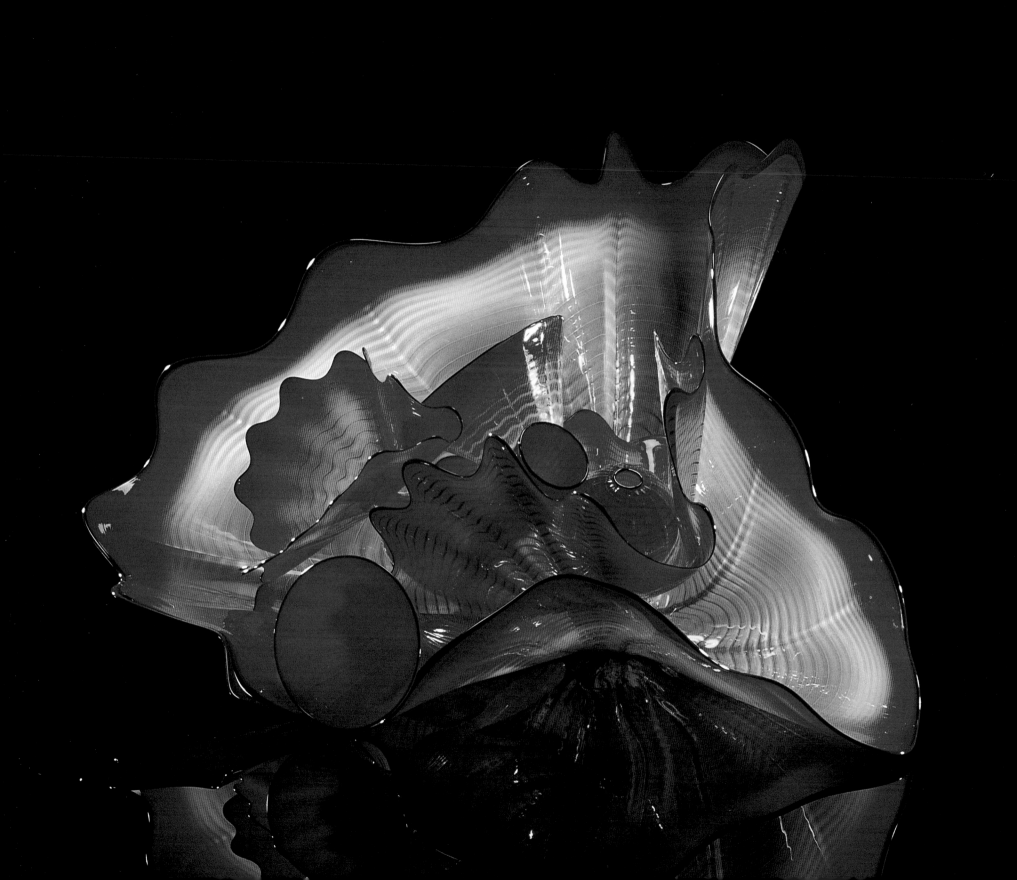

Blue Lavender Persian with Green Lip Wrap, 21 x 27 x 25 in., 1992.

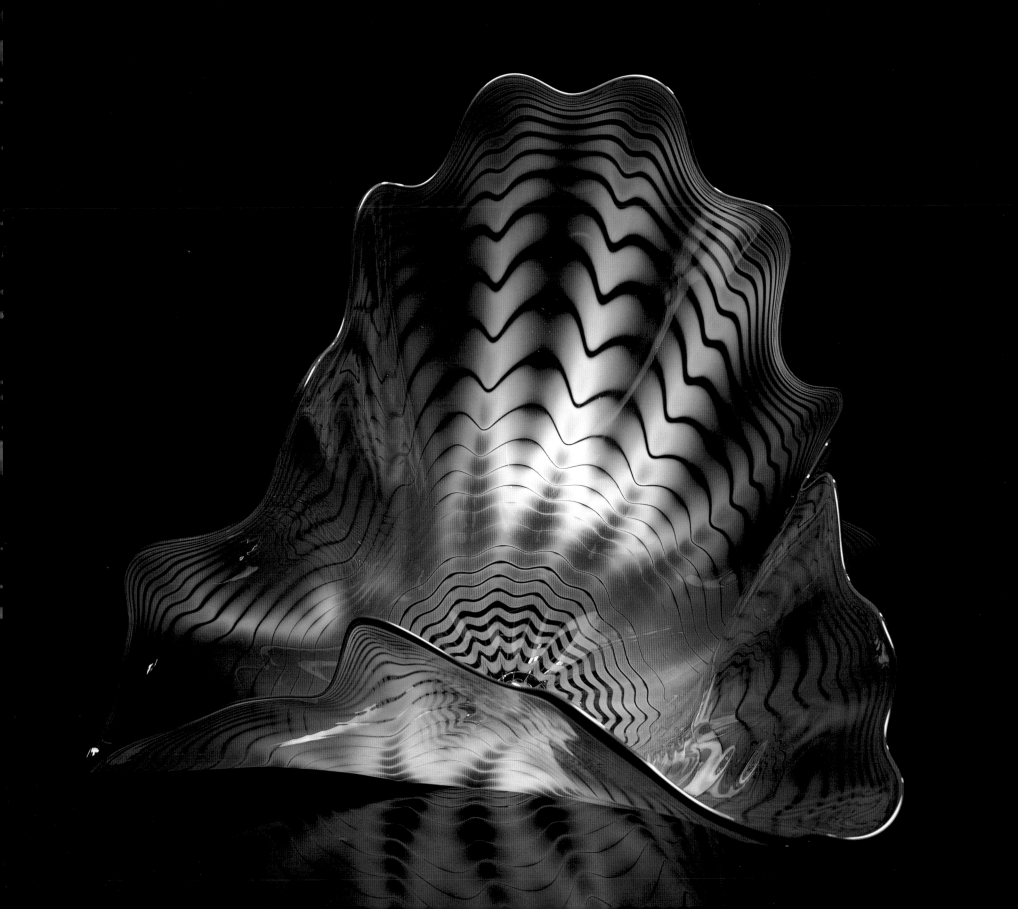

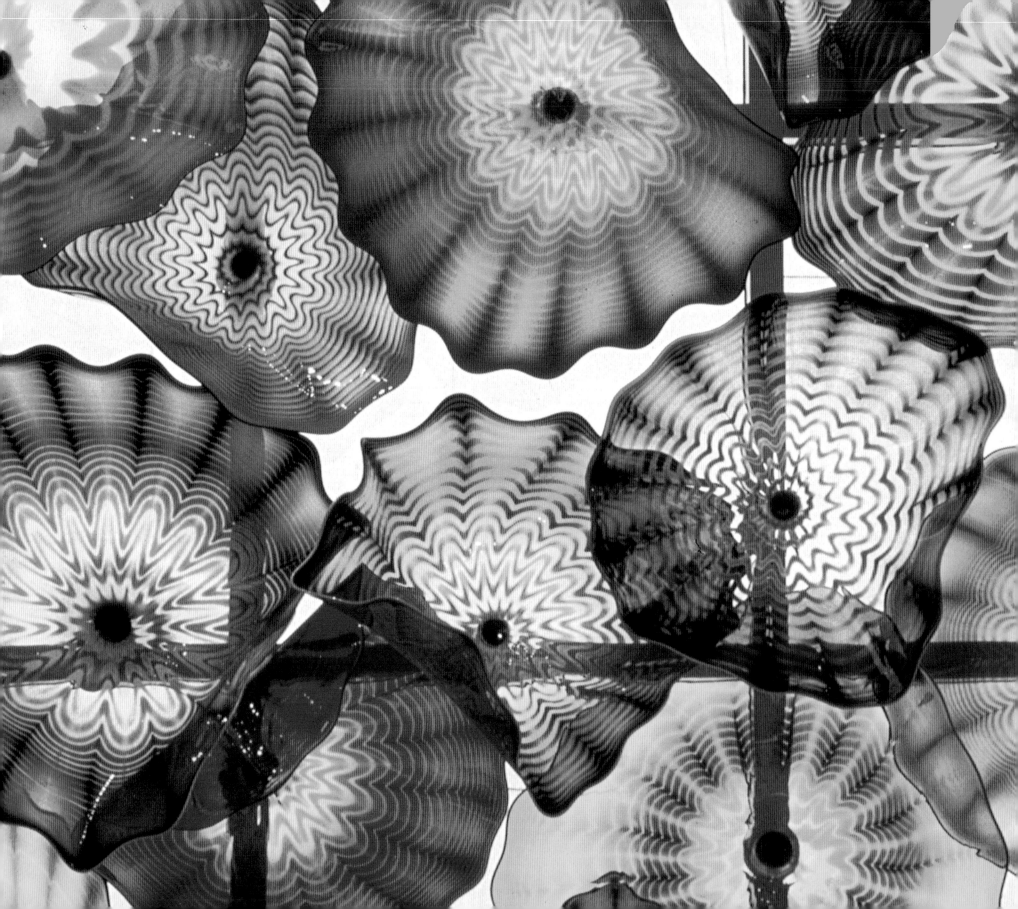

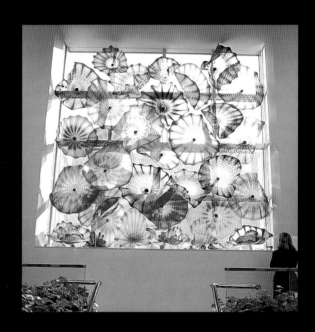

Malina Window, Little Caesar's Corporate Headquarters,
Detroit, Michigan, 16 x 16 ft., 1992.

Deep Purple Persian Set with Red Lip Wraps, 12 x 16 x 15 in., 1996.

Following pages: *Opaline and Persian Set with*

Oxblood Lip Wraps, 1994.

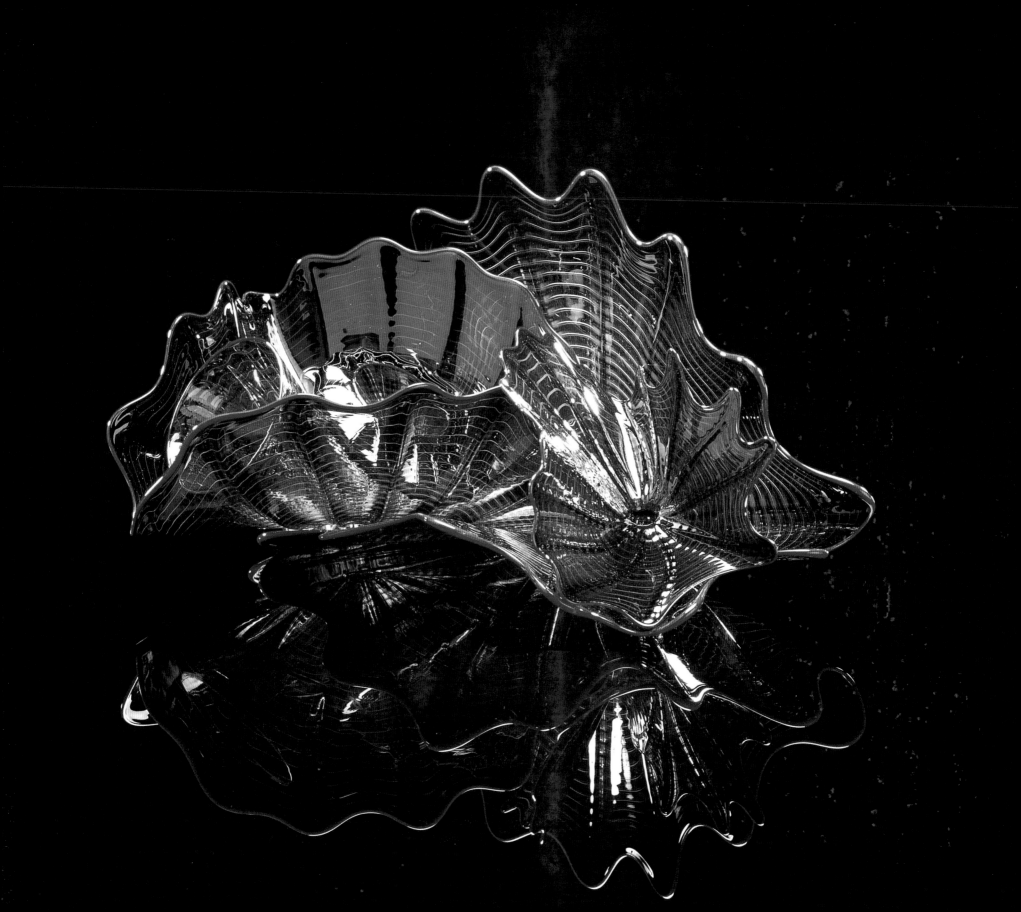

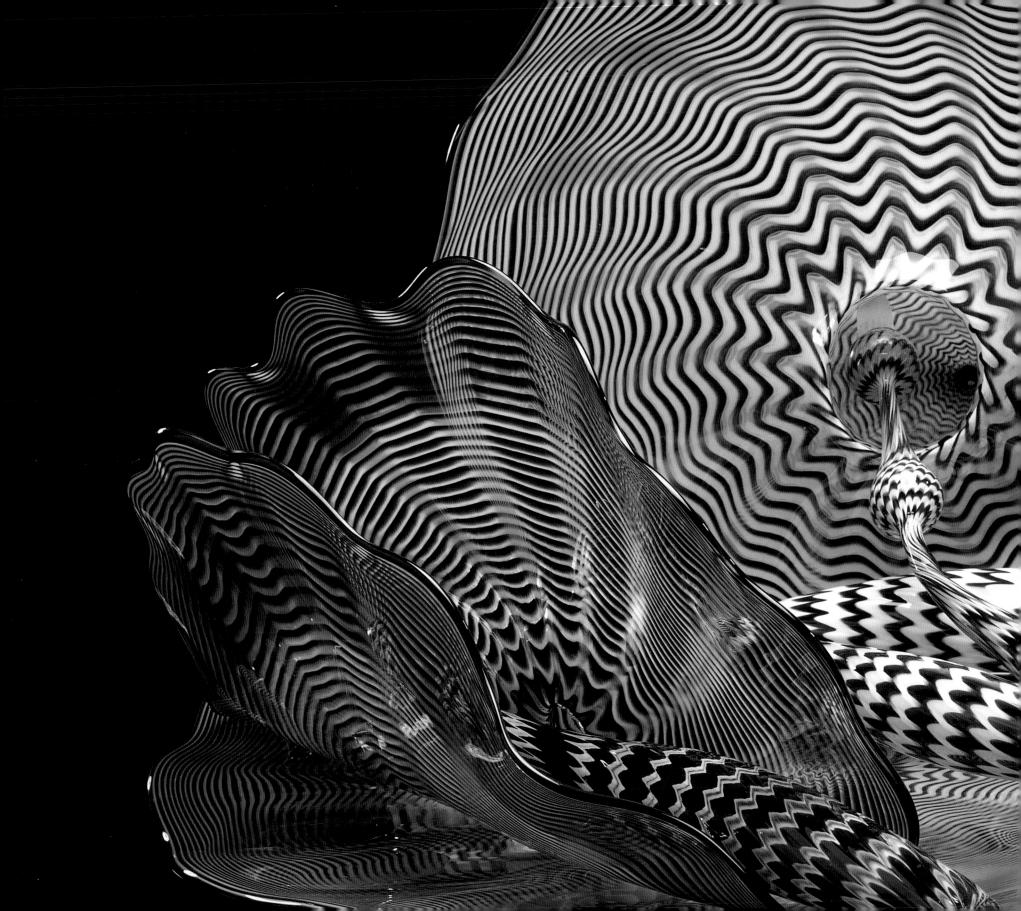

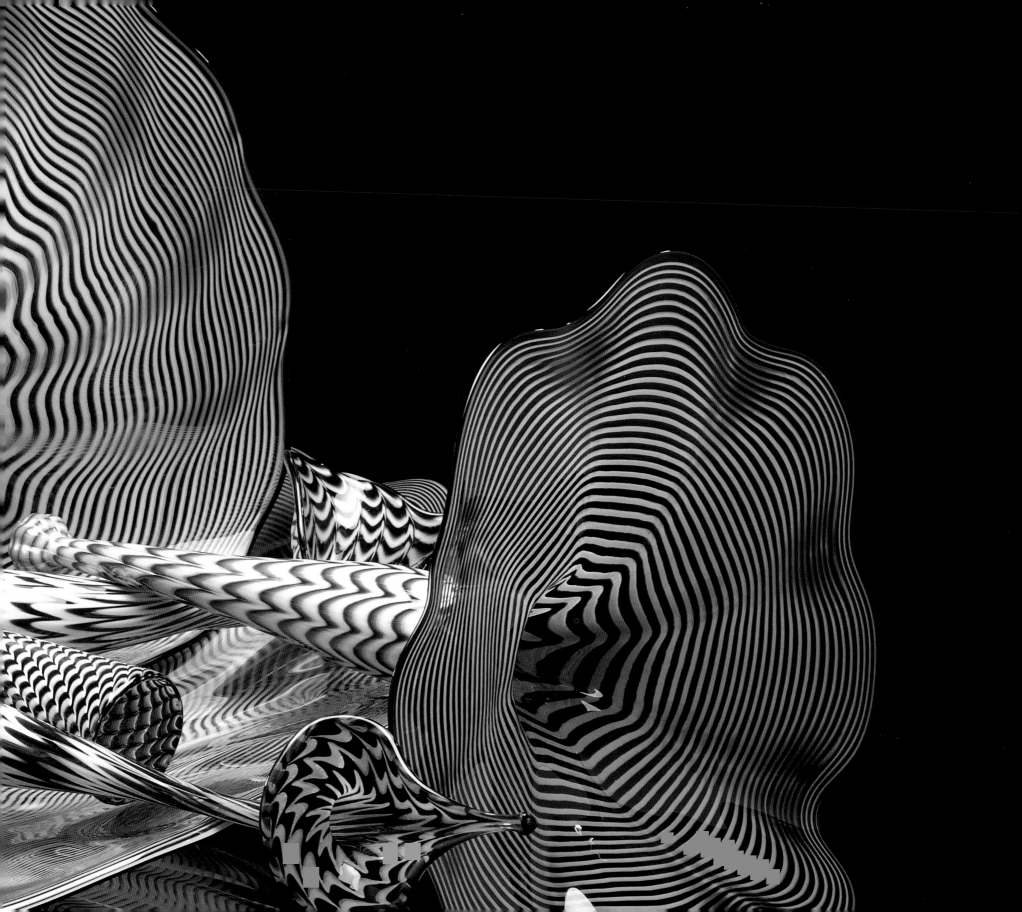

NOTES

¹ Inscription on a 14th-century Islamic mosque lamp in the collection of the Victoria and Albert Museum, London. W. B. Honey, *Glass*, Victoria and Albert Museum, London, 1946, p. 50.

² Yvonne Brunhammer, *Dale Chihuly: objets de verre*, Musée des Arts Décoratifs, Paris, France, 1986, p. 37.

³ Dale Chihuly, interview with Patterson Sims, December 12, 1995; and Dale Chihuly, interview with the author, May 9, 1996. Unless otherwise noted, all subsequent quotations by Dale Chihuly are taken from this interview.

⁴ Walter Darby Bannard in "Dale Chihuly," *Chihuly: Form from Fire* (with essays by Walter Darby Bannard and Henry Geldzahler), The Museum of Arts and Sciences, Daytona Beach, FL, in association with the University of Washington Press, Seattle, 1993, p. 11.

⁵ For the early history of glass, see Sidney M. Goldstein, *Pre-Roman and Early Roman Glass*, The Corning Museum of Glass, Corning, NY, 1979; Donald B. Harden (ed.), *Masterpieces of Glass*. British Museum, London, 1968; Dan Klein and Ward Lloyd (eds.), *The History of Glass* (with a foreword by Robert Charleston), Orbis, London, 1984; and Marianne B. Stern, *Early Ancient Glass*, Toledo Museum of Art, Toledo, 1991.

⁶ William Arrowsmith (trans.), *Petronius: The Satyricon*, The New American Library, New York, 1959, p. 58 (Book V, 50).

⁷ Dan Klein and Ward Lloyd, *The History of Glass*, p. 19.

⁸ Dominique Collon, *Ancient Near Eastern Art*, British Museum, London, 1995, pp. 177-187; and Ann Farkas, Achaemenid Sculpture, Nederlands Historisch Archaeologisch Instituut in het Nabije Osten, Istanbul, 1974, p. 46.

⁹ Illustrations of these reliefs are found in Pierre Amiet, *Ancient Near Eastern Art*, Harry N. Abrams, Inc., New York, 1977, pp. 426-431 and 558-561.

¹⁰ Dominique Collon, *Ancient Near Eastern Art*, pp. 188-210.

¹¹ The Roman emperor Constantine exempted vitriarii (glassmakers) and diatretarii (glass decorators) from all public levies in 337 while, one hundred years later, the Byzantine emperor Theodosius freed them from personal taxation as well. Dan Klein and Ward Lloyd, *The History of Glass*, p. 53-54, 58.

¹² Dan Klein and Ward Lloyd, *The History of Glass*, p. 55. The famous beaker preserved in the Victoria and Albert Museum in London, called the Luck of Edenhall, may be one of these Crusader souvenirs and evidently was prized enough by its owner to have had a special leather traveling case made for it. W. B. Honey, *Glass*, p. 47.

¹³ W. B. Honey, *Glass*, pp. 46-47; and Dan Klein and Ward Lloyd, *The History of Glass*, pp. 59, 65.

¹⁴ Dan Klein and Ward Lloyd, *The History of Glass*, p. 62

[15] Ibid., p. 63. British art historian W. B. Honey relates that some Damascan glass sprinklers (a flask with a constricted neck opening) were historically described as "bombs" or grenade-like containers for "Greek fire," although he did not believe such "elaborately-wrought vessels" would be used for such a purpose. W. B. Honey, *Glass*, p. 47.

[16] Ibid., p. 49.

[17] A Milanese traveler, visiting Jerusalem in 1480, noted in his journal that enameled glass "vases" from the Venetian island of Murano had been commissioned by officials in Damascus. Nearly a century later, Islamic-style Venetian glass was still in demand. Renaissance-period documents record that the Venetian ambassador at Constantinople, Marcantonio Barbaro, received an order for a number of Venetian mosque lamps made in the Islamic style. Ibid., pp. 53-54; and Hugh Tait, *The Golden Age of Venetian Glass*, British Museum, London, 1979, p. 12.

[18] David Talbot Rice, *Islamic Art*, Thames & Hudson, London, 1965, p. 137.

[19] Michelangelo Muraro and Andre Grabar, *Treasures of Venice* (translated by James Emmons), Editions Skira, Geneva, 1963, p. 12.

[20] Massimo Pallottino (ed.), *The Horses of San Marco*, Venice (translated by John and Valerie Wilton-Ely), Olivetti, Milan, 1979, p. 49.

[21] Michelangelo Muraro and Andre Grabar, *Treasures of Venice*, p. 3. This proposition was made less than 20 years after Venetians crusaders had participated in the sack of the Byzantine capital, which was finally rebuilt by the Byzantine Paleologue dynasty in 1261.

[22] Hugh Tait, *The Golden Age of Venetian Glass*, p. 12; and Attilia Dorigato, Murano Glass Museum (translated by Michael Langley), Electa, Milan, 1986, p. 18.

[23] W. B. Honey, *Glass*, p. 37; Ada Polak, Glass: Its Tradition and Its Makers, G.P. Putnam's Sons, New York, 1975, p. 31; and Donald B. Harden, Masterpieces of Glass, p. 130-131.

[24] Guido Perocco (ed.), *The Treasury of San Marco*, Venice, Olivetti, Milan, 1984, p. 13.

[25] Michelangelo Muraro and Andre Grabar, *Treasures of Venice*, p. 26.

[26] Ibid., pp. 10, 26.

[27] Guido Perocco, *The Treasury of San Marco*, Venice, p. 26.

[28] Ibid., pp. 129, 134, 49.

[29] Henry Geldzahler, "Dale Chihuly," *Chihuly: Form from Fire*, p. 13.

[30] Ibid., Holland Cotter, quoted, p. 73.

[31] For examples, see Mario Quesada (ed.), *L'arte del vetro*, Marsilio, Venice, 1992, pp. 116, 118, 146 (in the collection of the Kunstmuseum Düsseldorf, Germany).

[32] See Franco Deboni, *I vetri Venini* (with an introduction by Dan Klein), Archivi di arte decorative, Umberto Allemandi & Co., Turin, 1989, catalogue no. 90.

[33] Patterson Sims, *Dale Chihuly: Installations 1964 - 1992*, Seattle Art Museum, Seattle, 1992, p. 14.

[34] James Carpenter quoted in Linda Norden, *Chihuly Baskets*, Portland Press, Seattle, 1994, p. 21.

[35] David Bourbon quoted in Patterson Sims, *Dale Chihuly: Installations 1964 - 1992*, p. 62..

[36] Linda Norden, *Chihuly Baskets*, Portland Press, Seattle, 1994, p. 25.

[37] Tsai-Lang Huang, *Chihuly: Glass in Architecture*, p. 8.

[38] James Carpenter quoted in Linda Norden, *Chihuly: Baskets*, p. 22.

[39] Karen Chambers in "Dale Chihuly," *Chihuly: Form from Fire*, p. 17; and Michael Monroe in Dale Chihuly, Color, Glass and Form, p. 36.

[40] Friedrich Spuhler, *Islamic Carpets and Textiles in the Keir Collection* (translated and with an introduction by George Wingfield Digby), Faber & Faber, London, 1978, pp. 100-113.

[41] Ibid., p. 134.

SELECTED MUSEUM COLLECTIONS

Albright-Knox Art Gallery, Buffalo, New York
American Craft Museum, New York, New York
American Glass Museum, Millville, New Jersey
Amon Carter Museum, Fort Worth, Texas
Arkansas Art Center, Little Rock, Arkansas
Art Gallery of Greater Victoria, British Columbia
Art Gallery of Western Australia, Perth, Australia
Art Museum of Arizona State, Tempe, Arizona
Auckland Museum, Auckland, New Zealand
Australian National Gallery, Canberra
Azabu Arts and Crafts Museum of Tokyo, Japan
Baltimore Museum of Art, Baltimore, Maryland
Bellevue Art Museum, Bellevue, Washington
Birmingham Museum of Art, Birmingham, Alabama
Boca Raton Museum, Boca Raton, Florida
Boston Museum of Fine Arts, Boston, Massachusetts
Carnegie Museum of Art, Pittsburgh, Pennsylvania
Chrysler Museum of Fine Art, Norfolk, Virginia
Cleveland Art Museum, Cleveland, Ohio
Columbus Museum of Art, Columbus, Ohio
Contemporary Arts Center of Hawaii, Honolulu, Hawaii
Cooper-Hewitt Museum, Smithsonian Institution National Museum of Design, New York, New York
Corning Museum of Glass, Corning, New York
Crocker Art Museum, Sacremento, California
Currier Gallery of Art, Manchester, New Hampshire
Dallas Museum of Art, Dallas, Texas
De Cordova Museum and Sculpture Park, Lincoln, Massachusetts
Denver Art Museum, Denver, Colorado
Dowse Art Museum, Aotearoa, New Zealand
Elvehjem Museum of Art, University of Wisconsin, Madison, Wisconsin
Everson Museum of Art, Syracuse, New York
Fine Arts Museum of the South, Mobile, Alabama
Galerie d'Art Contemporain, Nice, France
Glasmuseum Ebeltoft, Ebeltoft, Denmark
Glasmuseum Frauenau, Frauenau, Germany
Glasmuseum Wertheim, Germany
Grand Rapids Museum, Grand Rapids, Michigan
Haaretz Museum, Tel Aviv, Israel
Hawke's Bay Exhibition Centre, Napier, New Zealand
High Museum of Art, Atlanta, Georgia
Hokkaido Museum of Modern Art, Hokkaido, Japan
Honolulu Academy of Art, Honolulu, Hawaii
Hunter Museum of Art, Chattanooga, Tennessee
Indianapolis Museum of Art, Indianapolis, Indiana
Israel Museum, Jerusalem, Israel
J.B. Speed Art Museum, Louisville, Kentucky
Jesse Besser Museum, Alpena, Michigan
Jundt Art Museum, Gonzaga University, Spokane, Washington
Kestner Museum, Hanover, Germany

Krannert Art Museum, University of Illinois, Champaign, Illinois
Kunstammlugen der Veste Coburg, Germany
Kunstindustrimuseum Kopenhagen, Denmark
Kunstmuseum, Dusseldorf, Germany
Leigh Yawkey Woodson Art Museum, Wausau, Wisconsin
Lobmetr Museum, Vienna, Austria
Los Angeles County Museum of Art, California
Lowe Art Museum, Coral Gables, Florida
Lyman Allyn Art Museum, New London, Connecticut
Madison Art Center, Madison Wisconsin
Manawatu Museum, Palmerston North, New Zealand
Metropolitan Museum of Art, New York, New York
Milwaukee Art Museum, Milwaukee, Wisconsin
Morris Museum, Morristown, New Jersey
Museo del Vidrio, Monterrey, Mexico
Musee d' art Moderne et d'art Contemporain, Nice, France
Musee des Arts Decoratifs, Palais du Louvre, France
Musee des Arts Decoratifs, Lausanne, Switzerland
Musee des Beaux Arts et de la ceramique, Rouen, France
Museum Bellerive, Zurich, Switzerland
Museum Boyman-Van Beuningen, Rotterdam, The Netherlands
Museum fur Kunst und Gewerbe, Hamburg, West Germany
Museum Furkunsthandwerk, Frankfurt, Germany
Museum of Art and Archeology, Colombia, Missouri
Museum of Art, Fort Laderdale, Florida
Museum of Art, Rhode Island School of Design, Providence, Rhode Island
Museum of Contemporary Art, Chicago, Illinois
Museum of Fine Art, Boston, Massachusetts
Museum of Modern Art, New York, New York
Museum of Modern Art, Nice, France
Muskegon Museum of Art, Muskegon, Michigan
National Museum, Stockholm, Sweden
National Museum of American History, Smithsonian Istitution, Washington, D.C.
National Museum of Modern Art, Kyoto, Japan
New Orleans Museum of Art, New Orleans, Louisiana
Newport Harbor Art Museum, Newport Beach, California
Niijima Glass Arts Center, Niijima, Japan
Palm Beach Community College Art Museum, Lake Worth, Florida
Parrish Museum of Art, Southampton, New York
Philadelphia Museum of Art, Philadelphia, Pennsylvania
Phoenix Art Museum, Phoenix Arizona
Portland Art Museum, Portland, Oregon
Power house Museum, Sydney, Australia
Princeton University of Art Museum, Princeton, New Jersey
Provincial Musee Sterckshof, Antwerpen, Belgium
Renwick Gallery, National Museum of American Art, Smithsonian Institution, Washington D.C.
Robert McDougall Gallery, Christchurch, New Zealand
Royal Ontario Museum, Toronto, Canada
Saint Louis Art Museum, Saint Louis, Missouri
San Francisco Museum of Modern Art, San Francisco, California
San Jose Museum of Art, San Jose, California
Scitech Discovery Centre, Perth, Australia

Seattle Art Museum, Seattle, Washington
Shimonoseki City Art Museum, Shimonoseki, Japan
Singapore Art Museum, Singapore
Smith College Museum of Art, Northhampton, Massachusetts
Spencer Museum of Art, University of Kansas, Lawrence, Kansas
Suomenlasimuseo, Riihimaki, Finland
Tacoma Art Museum, Tacoma, Washington
Taipei Museum of Fine Arts, Taiwan
The Detroit Institute of Art, Detroit, Michigan
Toledo Museum of Art, Toledo, Ohio
Umelecloprumsylove Museum, Prague, Czechoslovakia
University Art Museum, University of California, Berkeley, California
University of Michigan, Dearborn, Michigan
Utah Museum of Fine Arts, Salt Lake City, Utah
Wadsworth Atheneum, Hartford Connecticut
Victoria and Albert Museum, London, England
Waikato Museum, Hamilton, New Zealand
Walker Hill Art Center, Seoul, Korea
Whatcom Museum of History and Art, Bellingham, Washington
White House Craft Collection, Washington, D.C.
Whitney Museum of American Art, New York, New York
Yale University Art Gallery, New Haven, Connecticut
Yokohama Museum, Yokahama, Japan

PUBLIC AND CORPORATE COLLECTIONS AND INSTALLATIONS

Persian Installations *

American Embassy, London, England
American Embassy, Paris, France
Australian Arts Council, Sydney, Australia
Bass Brothers Enterprises, Forth Worth, Texas
California College of Arts and Crafts, Oakland, California
Chancellor Park, San Diego, California *
Chase Manhattan Bank, New York, New York
Columbia Tower Club, Seattle, Washington
Columbus Visitors' Center, Columbus, Indiana *
Corning World Headquarters, Corning, New York
Crafts Council of Australia, Sydney
Davis, Wright, Tremaine, Seattle, Washington
Dreyfus Corporation, New York, New York
Fleet National Bank, Providence, Rhode Island
Foster & Marshall, Inc., Spokane, Washington
Frank Russell Building, Tacoma, Washington *
Genesee Partners, Bellevue, Washington
Dr. Eugene W. Goertzen, Seattle, Washington *
Gonzaga University, Spokane, Washington
GTE Telephone Operations Headquarters, Irving, Texas *

The Hearn Company, Chicago, Illinois
Harold Hess Company, Inc, Philadelphia, Pennsylvania
Hillhaven Corporation, Tacoma, Washington
Hyatt Hotel, Adelaide, Australia *
IBM Corporation, New York, New York
Indonesian Embassy, Washington, D.C.
Japan-American Society, UNICO Properties, Inc., Union Square, Seattle, Washington *
Johnson Wax Collection, Racine, Wisconsin
King and Spalding, Washington, D.C.
Francis and Sydney Lewis Foundation, Richmond, Virginia
Little Caesars World Headquarters, Detroit, Michigan *
Liz Claiborne Store, New York, New York *
Madison Stouffer Hotel, Seattle, Washington
MCI Communications World Headquarters, Washington, D.C.
Mercer International, Inc., Vancouver, British Columbia
Microsoft Corporation, Redmond, Washington
National Geographic Society, Washington, D.C.
Ohio Arts Council, Library of Science and Engineering, Ohio State University, Columbus, Ohio
Owens-Corning Fiberglass, Toledo, Ohio
Paccar, Inc., Bellevue, Washington
Pacific Lutheran University, Tacoma, Washington *
Pilchuck Glass School, Stanwood, Washington
The Prudential Insurance Company of America, Newark, New Jersey
Rainbow Room Pavilion, Rockefeller Center, New York, New York
Ritz-Carlton Millenia Hotel, Singapore
Safeco Insurance Companies, Seattle, Washington
Seaman's Bank, New York, New York
Seattle Aquarium, Seattle, Washington *
Seattle First National Bank, Seattle, Washington
SS Oceanic Grace, Tokyo, Japan
Shaare Emeth Synagogue, St. Louis, Missouri
Sheraton Seattle Hotel and Towers, Seattle, Washington
Sheraton Hotel, Tacoma, Washington
Simpson Investment Company, Seattle, Washington
Simpson Paper Company, San Francisco, California
Stone Container Corporation, Chicago, Illinois
Swedish Hospital, Seattle, Washington
Tacoma Financial Center, Tacoma, Washington
Tropicana Products Inc., Bradenton, Florida
Union Station, Tacoma, Washington (until 1999) *
United States Border Station, Blaine, Washington
University Hospital, Seattle, Washington
University of Puget Sound, Tacoma, Washington
Meany Hall, University of Washington, Seattle, Washington
U.S. Bank Centre, Seattle, Washington *
U.S. News and World Report, Washington, D.C.
Vitro Vidrio Plano, Monterrey, Mexico
Washington State Convention Center, Seattle, Washington
Washington University Medical Center, St. Louis, Missouri
Weyerhauser Company, Tacoma, Washington
Yasui Konpira-gu Shinto Shrine, Kyoto, Japan *

The type face in this book is Adobe Garamond.
First printing, 1996, 5,000 copies.
Second printing, 1999, 10,000 copies.
Printed by C&C Offset Printing Co. Ltd., Hong Kong.

Editors:
Helen Abbott
Kyra Butzel
Barry Rosen
Megan Smith

Designer:
Lisa Pettit

Photographers:
Dick Busher 6, 14, 25, 27, 28-29
Eduardo Calderon 50-51
Shaun Chappell 11, 85, 91
Francis' Studio 56, 57
Claire Garoutte 18, 31, 36, 37, 39, 43, 44-45, 60-61, 67, 71, 77, 81
Scott Hagar 40, 41, 82, 83
Russell Johnson *cover flap,* 20, 48, 49, 64, 72, 73, 88, 89
Terry Rishel *cover, title page,* 39, 53, 55, 59, 63, 65, 68-69, 78-79, 92-93
Roger Schreiber 7, 16, 32-33, 34-35, 46-47
Michael Seidl 35
Charles White 95
Robert Whitworth 75, 87